Robert Dixon
940 Churchill Blvd
apt. 205
St. Lambert, Quebec
J4R 1N1 (514) 671-8061.

Recieved: March. 1988.

WILDLIFE AND WILDERNESS
AN ARTIST'S WORLD

WILDLIFE AND WILDERNESS
AN ARTIST'S WORLD

KEITH SHACKLETON

SALEM HOUSE PUBLISHERS

TOPSFIELD, MASSACHUSETTS

First published in the United States
by Salem House Publishers 1986
462 Boston Street, Topsfield, MA 01983.

Text © Copyright 1986 by Keith Shackleton
The paintings and sketches reproduced herein are
© Copyright Keith Shackleton

Library of Congress Catalog Card Number: 86-60819

ISBN 0 88162 217 6

Designed by Nigel Partridge

Phototypeset by Bookworm Typesetting, Manchester.
Printed and bound in Italy by New Interlitho, Milan.

Wildlife and Wilderness: an Artist's World is sponsored by Shell
UK Ltd. The publishers are deeply grateful for this generous
support, as a result of which they have been able to reproduce
more of Keith Shackleton's paintings than would otherwise
have been possible.

FRONTISPIECE: IN LANCASTER SOUND

Author's Acknowledgements

At the outset this seemed a daunting task. Paintings are painted and they go their separate ways. Unless blessed with a methodical and organized turn of mind, conspicuous for its absence in my case, it is no easy task to recall where they all went. About 50 were needed and at first I could only recall the immediate whereabouts of five!

The situation reminded me of a fellow painter who specialized in vast portrait group assemblies for service messes, depicting 30 or 40 officers in full dress uniform, all the regimental silver on the table, and the colours and battle honours behind. Each separate face had to be a speaking likeness, and each complete picture took him about four months of nine-to-five painstaking drudgery and inevitable criticism. "Where on earth do you begin," I once asked, "after putting your three-foot by six-foot canvas on the easel?"

It seemed to be a question that had never come his way before and he thought a long time before he replied: "Well, I generally just go and make myself a cup of instant coffee . . ."

There is in fact nearly always some way of getting over the first hurdle. Coffee may be one; in the case of this book it was the very generous help of other people. The first breakthrough was when Bob Lewin, President of Millpond Press Inc. in Florida, sent me a batch of large format transparencies to start the collection. He provided more than a third of all that were needed, and several were from pictures he had published earlier as limited edition prints. Added to such material help came all the enthusiasm one could wish for from Clive Holloway, the Publisher, and there is no better stimulant.

From then on I began contacting others, and all received the request in the same way, with help and advice of the most welcome and valuable kind.

Most painters are aware of the patronage and encouragement of industry, and in a general way I would like to mention this here. But as far as this book goes, Shell UK Ltd. and its divisions, Shell UK (Oil) and Shell Expro have gone out of their way to help. The Medici Society, Royle Publications and the Tryon Gallery have kindly provided transparencies from previously published work.

In addition to this a number of good friends have allowed pictures to be photographed in their own homes and offices, both in Britain and the United States, pictures most of which have not been published before, and I would like to set these out here for special mention: Lord Buxton, Mr and Mrs Tim Clutton-Brock, Mr and Mrs Andrew Green, Sir Jack Hayward, Eric Hosking, Richard Hunting, Sir Giles Loder, the Port of London Authority, Geraldine Prentice, Esperanza Rivaud, the Officer Commanding – 45 Commando, Royal Marines, the Royal Society for the Protection of Birds, Patricia Wells, Charles Whitehead and Mr and Mrs Foster B. Whitlock.

Had it not been for Nicola Beresford who offered to type manuscripts from recorded tapes, it would have taken something more stimulating than coffee to negotiate the first hurdle.

And finally my gratitude to Jacq, my wife. Anybody who knows the pattern of living in what is a house, a studio, an office, workshop and meeting place all at the same time, will understand the extent of both her contribution and her patience.

CONTENTS

For Jacq: Sarah, Jason and Jasper.

For me painting has long been a deep interest, as long in fact as my interest in both wildlife and wilderness.

Finding all three subjects presented together between these two covers proved somewhat irresistible. As a painter and a naturalist I have had the good fortune to familiarise myself with them all and to understand very fully just how valuable they are.

Keith Shackleton has painted this general subject matter all his life and in many far flung places. But by confining this book predominantly to artistic interpretations of the greatest of all this planet's areas of true wilderness, the polar regions, he seems to have made a very true and telling statement in favour of their conservation for all mankind.

To anybody who dabbles in paint, no matter what the medium, there has to be fascination in knowing the thoughts of others engaged in the same work. Much of what he describes is very close to what I have felt myself, but here and there are off-beat and rather personal thoughts, reminiscenses, painting discoveries and disclosures about the subject itself, that make every essay different and put a refreshing new slant on one's assessment of pictures in general.

In his Thoughts on Painting there is a certain amount of rocking the boat. One or two artistic shibboleths are questioned, but in the kindest way. I am left wondering, for instance, why I started with watercolours and not oils when the latter is obviously so easy to handle. Is there something essentially British about having to do things the hard way?

The principles discussed here and the paintings that illustrate them could, I suppose, be equally relevant to artistic effort directed at any subject. But the appeal, for me anyway, must stem from this particular one. I have never been able to decide if I became interested in wild animals and birds because they lived in beautiful places or that I am drawn to a wilderness because wildlife was to be found there. An inseparable bond of interdependence exists between them.

What is, however, very certain is that the world is not just a better place for both, but without them the light would go out. Quality of life for the human race would become a mere existence and there would no longer be any escape for the human spirit.

Charles

MS LINDBLAD EXPLORER

There is no way that I can embark upon this book without mention of a most unusual little ship that in her own special way lies behind most of the pictures.

The Acknowledgements chapter is for people, and I felt that the Introduction should establish some thoughts about painting. Had the book contained much colourful, land-based tropical subject matter, these two chapters might well have sufficed. But it is principally a polar collection, and the ship is very much involved. *Lindblad Explorer* has been in on practically every one of these pictures in their conception, logistically she has been the way and the means, and she certainly merits a mention all her own.

Later on in the text there will be occasional references to "us" and "we"; these will refer to the ship's company in all its arcane groupings, while a reference to "the ship" speaks for itself, and the ship is the *Lindblad Explorer*.

By coincidence, a book called *Ship in the Wilderness,* produced by Gaia Books, is to be published by J M Dent & Sons at the same time as this. It sets out in some detail, with excellent photographs by Jim Snyder, the fifteen-year story of this very ship, and though it is pointless to go over the same ground here, a brief mention is necessary if only to explain how so many pictures from such a far-flung and somewhat inaccessible lot of places should come to be painted by one person.

In 1969 I was taken on as "naturalist" on the ship's maiden voyage from Southampton to the Antarctic, and have stayed with her regularly until her final triumph as the first passenger vessel to make the transit of the Northwest Passage in 1984. "Naturalist" in my particular case consisted mostly of driving the landing craft. There were generally much more scholarly ones around to ease me off the academic hook. "Naturalist" is a term which is destined to cause confusion and misinterpretation . . .

I once had to present my passport to an immigration officer in Lima, Peru, and his eye lit upon artist/naturalist under the heading of Occupation.

"I have to warn you, Señor," he said with utmost solemnity while closing the passport and handing it back, "we have laws in this country concerning indecent exposure . . ."

A few of the pictures that follow have no more to do with *Lindblad Explorer* than with indecent exposure, but they are few and will be obvious. For the majority though, she must be thought of as a presence never far away and always very relevant; moreover, she has kept me fuelled with ideas and subjects to last a lifetime.

One final personal acknowledgement has to be made here because the name is inseparable from the ship, and that is to record my gratitude to Lars-Eric Lindblad himself for putting this little vessel on the high seas with me aboard, and for the continuing inspiration that followed.

SOME THOUGHTS ON PAINTING

This is a book of pictures and they all have two things in common. They are, like the claim of pavement artists, "all my own work", which is one. The other is that they have been chosen out of a fairly wide range of possibles to illustrate a theme of wildlife and wilderness.

Emphasis is on oceans, mountains and, in particular, high latitudes north and south, so it is essentially a polar book. In some cases the choice of paintings has not been mine and no attempt has been made to demonstrate versatility of subject, any more than to trace the progress of a painting style from the cradle – the pictures are all too recent. But it could be said that there is a third link between them. Because I so dearly love their subject matter, a lot of my favourite pictures have found their way into this collection.

Each picture is qualified by notes, something like a brief essay on its subject but from different angles, some artistic, some zoological, some geographic and some just reminiscent and very personal. And all this in the belief that to know something of what a painter was thinking as he

painted can only make for added interest. To know what sparked off activity in the first place must surely have some relevance to the finished picture for those who look at it. It also reveals that forces other than the appeal of pure aesthetics can play a part.

The reason why it is essentially polar in character is ridiculously simple. I love the tropics and the tropical style of existence but when it comes to painting and the visual motivation a subject exerts, the ice surpasses everything: the ice and, of course, the sea.

By association, all that lives in these places exerts a kindred attraction. Like so many painters who passionately care about their subject for its own sake, I find in it all the drama I need. In true wilderness, reality goes hand in hand

ADÉLIE PENGUINS

with the abstract and yet my artistic interpretations of it would certainly be described as representational. I believe that to be a good abstract painter one needs to see in painting a commitment in itself, bereft of any other distracting interests that might demand, through sheer loyalty or affection, some sort of conformity with the "realism" of a subject.

Though it is a book of pictures it is not a book on how to paint, and here I must come clean with an admission if only to clear my own conscience from the outset.

I never went to an art school. No great significance is intended by this revelation beyond the fact that never having been taught under the accepted curriculum, I am in no position to point the way to others. It is true we had some very fine teachers at ordinary school, but that was a once a week, twice a week sort of affair and very long ago. We never went deep. They sought to teach us to draw mostly and to paint a little. Time was short for such refinements as artistic appreciation, history of art or development of style, let alone peripheral and infinitely debatable considerations like "the importance of suffering to the creative mind".

In some ways I think I was lucky. The hair-shirt purely on spiritual grounds I would find hard to justify. Painting pictures should be, and happily is, fun. For me it is such fun in fact that I still feel there is something vaguely indecent about my trade, as though I were living on immoral earnings. Someone, somewhere deserves gratitude for a situation where a livelihood can be secured from a pursuit that would continue unchanged if there were no need to work at all.

For all that, to indulge this fun can well mean hardships and at times it did, but never suffering. I was always aware of the uncertainty inherent in any artistic career, and though the tradition of starvation in a garret was always a possibility – indeed a probability in my parents' eyes, the prospect of frustration driving me to leap to my death from the dormer window never entered my head. Neither, for that matter, did the thought of being hailed a genius as soon as the coroner had cleared up the details.

Having set this down, it is fair to continue with another disclaimer. Every thought expressed concerning the appeal of certain subjects, the attempts to achieve a goal, even the assessment of the results, are entirely personal. They may make sense to the reader, or they may not, so be it. They are mine and they are all I have to offer.

I now feel a lot easier, for of all the ingredients that go to making painters, good or bad, acclaimed or otherwise, the only one that matters is sincerity with oneself and this simply means painting, or trying to paint, from the heart, and doing one's own thing. Influences are bound to raise their heads because this is the way life works. The danger lies in imitating something because people seem to want it, or consciously avoiding something because it is supposedly

out of fashion. As sure as tomorrow's dawn will break, opinions of any finished work will cover the whole spectrum from unreserved admiration through indifference to vomiting, but if it is sincere it has at least some built-in integrity that can never be denied.

This, I find, is something worth clinging to. Art has a refreshing shortage of parameters for judgement. It cannot be accepted or rejected on any usual standards of weights and measures. It is a thing of personal preference and personal taste and thereby offers inexhaustible possibilities for painting, sculpting, writing and talking the unintelligible. Against such a background, a simple ungarnished truth stands out like a jewel.

When I was a boy, there was considerable importance laid on the craft side of drawing and painting. They sought to teach one how to handle the tools and get the best out of them, and I believe this trend, having passed through some curious metamorphoses on the way, is now returning – and welcome. One of the notions I found hardest to understand, but often heard voiced, was that any sort of manual dexterity was not be trusted. It was deemed to be slick and superficial, even "commercial", the most damning indictment of all. We must learn, as it were, to express ourselves from a distance – carefree, abandoned, non-conformist, wielding paint sprays, buckets and blunt instruments out of which, by the intervention of fate, a "masterpiece" might appear. Then we were expected to feel the deep fulfilment of a skilled task well done. I can readily understand that it could be entertaining and might also produce, by the law of averages, amusing and even decorative results. But I always had the feeling that such exercises belonged more to the realm of psychiatric therapy than painting and that it was less than honest to involve "artistic temperament" and "vagaries of genius" as an essential ingredient for the work. To put it down to letting off steam, kicking an empty can along the street or just plain exhibitionism would have been infinitely closer to the truth.

Plumbers, chartered accountants, even undertakers I am sure, all have temperament as well. And so does everybody else who works with their head and their hands. There have to be days when a plumber will plumb with magic in his fingertips; when all is filled with joy and the heart with song as the pipes go together, and there will be days when he repeatedly hits his thumb with the wrench or burns it with the blowlamp and wishes he had never got out of bed. Artists are just the same. They too suffer from what could just as fairly be called "plumbing temperament" and, like plumbers, must learn to live with it if their skill is also their meal ticket.

I can recall days when I seemed unable to put a foot wrong. Ideas would fall like ticker tape on Wall Street to be set down in paint with boldness, immediacy and success. The studio felt to be humming with intermeshed achievement and providential intervention. Even the telephone

KELP GULL

would ring at convenient moments. A cheque would fall through the letterbox instead of a tax demand, and it seemed that the muse, like an exuberant fiddler on the capstan-head, was orchestrating my doings to the advantage of all mankind, and me in particular.

Then there are the other days.

They might begin by spilling the early morning tea over last night's finished drawing, pass through a long period of correction, indecision, creative sterility and general ineptitude to end by rinsing a brush in a remedial whisky and soda because it was standing next to the turps. The unfair thing is that had I allowed one of these days to break the fragile bounds of reason, run out into the woods and blown my brains out, people would have simply nodded their heads sagely and murmured "He was an artist, you know," as if this explained it all. What I could never understand was why artists should be singled out and credited with a brand of mental instability denied to other walks of life.

Here is another instance. I was lying one day under my boat which was hauled up on the foreshore by the cottage. I was scraping off the barnacles and giving her bottom a little of the "broad flat treatment" with antifouling paint and a three-inch brush.

The tide was making and a fishing boat passed by down the creek a couple of hundred yards away with two men in it. They were conversing over the thump of an air-cooled diesel engine which meant they were all but shouting, and voices carry with incredible clarity over still water.

"Look at him over there – he looks busy."

I heard every syllable and it was clearly me because "over there" contained no other living soul.

"Scraping off barnacles," went on the voice as if explanation were needed. "You know who he is don't you?"

I was all ears . . .

"It's that mad hermit artist."

Now little snatches of this kind, genuinely unfettered by insincerity, are always valuable under the see-ourselves-as-others-see-us analogy. So I rose from under the bilge and gave them a deep bow which probably confirmed their opinion beyond the range of doubt. But the interesting thought was simply this. I have never, I think, given any justification for being thought mad, or for that matter a hermit, but because I was an artist I had to be both.

Now I believe this attitude has much to do with the wilder side of artistic lifestyle and expression, having hijacked in the popular view the simple desire of people to try to paint pictures of lovely things because they are good to look at.

This is where it really begins. If the lovely things are important enough, and indeed lovely enough, and the artist feels a desire to pay some form of homage or tribute, something must be astir. If that person has what Konrad Lorentz describes as "gestaltperception", a natural ability to analyze shapes, see shapes within shapes and distil their

significance, things are warming up nicely. Then bringing it all to the boil must surely call for the flame of actual pencilcraft, brushcraft or whatever.

Many, I am sure, would disagree, but to me it seems axiomatic that if you seek to portray or interpret something in paint, you need both tools and ability as well as inspiration. I would hesitate to suggest which of the three is most important, but to miss out any one would seem like a concert pianist attempting a Chopin sonata with a doughnut in each hand.

All these pictures are oil paintings and I have painted nothing else since childhood. There are sound reasons for being in such a rut and several of them, but much the soundest is that water colours are too difficult.

Water colours are for orderly minds, gestaltperception of the most clinical kind, the patience of Job and tremendous natural ability. I find it nothing if not prudent to go through a careful stocktaking of one's shortcomings before embracing this horrendously unforgiving medium.

It is sad to have to say this but it is nonetheless true. Water colours appear to have achieved their ascendancy right from the nursery, simply because in general, paints mixed with water make less mess on carpets. Overtaxed mothers driven witless by other responsibilities can do without oil-bound Rose Madder and half a pint of linseed on the chintz. Very, very few of the young therefore begin

with oils, so they miss the chance of experimenting with a medium that will more or less do what you want and thereby extend the welcome hand of encouragement.

But I just love water colours – other people's water colours – to look at. I wish more than anything that I could handle them. A lot of my best friends are water colourists. I envy all of them and the only consolation I can salvage is that of knowing that I have at least demonstrated the good sense to known when I am licked.

All these pictures then are oils and most of them are a

WANDERING ALBATROSS

great deal larger than they need be. I am enslaved by a passion for painting big pictures which I shall elaborate on later in the book. Moreover they are not painted on canvas but on hardboard, a substance that enjoys a very low regard in purist circles but nonetheless can offer a surface of unbeatable sympathy to brush work at about one eighth of the price and has other advantages. Let me list a few.

If when a picture is complete, the composition is deemed to be lopsided or topheavy, an inch or two may be sawn off one side, the top or the bottom, to restore the visual harmony. For throwing in and out of small boats and Landrovers, hardboard is a much more durable material, with a much longer life.

Recently an old painting was returned to me for restoration from a ruined safari lodge in Uganda where it had apparently been impaled several times with a spear (nothing if not an unusual comment on a painting). Because it was on hardboard however, I was able to fill the spear holes with polyfilla from the DIY shop and paint over the damage. Had it been on canvas, the spear would have left those sinister L-shaped rents, if not cut it clean in half – not that it would have mattered greatly, because white ants would already have devoured everything but the paint and I would have had to apply for a mortgage to meet the costs of restoration.

Finally, if a picture seems doomed to failure and all hopes of making anything of it have ebbed away, it may be slow-marched off to the workshop and rubbed down with a power sanding machine. This treatment not only obliterates sickly memories, but leaves a painting surface of sheer perfection for another attempt. Deep down under some of the pictures in this book lie the mortal remains of such failures, and I tend to see each one thereafter as endowed with the triumphant qualities of the Phoenix.

Returning to the matter of medium, to lack an orderly mind also implies a lack of the ability to visualize. A good water colourist must know exactly what is wanted for the finished work and do it. There is no going back. A water colour must work first time, or fail. Oils impose no such restriction, so visualizing to an oil painter is simply trying something for size. If you like it, keep it. If not, wipe it off. Moreover, even time seems on the side of oils, for the more they are messed about with the more interesting they tend to become, because of an ever-richening deposit of paint referred to grandly as "patina".

Somewhere between the two extremes come acrylics.

The advantages of acrylics as a medium seem at the outset enormous – the cleanliness of water colours combined with all those seductively patina-promoting possibilities of oils. A lot of my friends embraced the new thing with open arms and even sought to convert me. To my credit I did at least try. But there seems a time in life when the lure of experiment, like the zest for competition, begins to evaporate. Some would see in it the late dawnings of real

wisdom, the less charitable would take it as the threshold of dotage. However the diagnosis went for me, it turned out to be an inauspicious moment to launch out on acrylics.

I only tried once. Unaware of the ferocious drying properties, I laid a favourite brush down to go and put on the kettle. When I returned with the tea, the brush had transformed itself irretrievably into a blunt harpoon. That was enough.

I realized then that acrylics, too, are for ordered minds. The similarity to oils is a masquerade. They are in fact no more than a vicious extension of the dreaded water colours and should carry a warning for both children and the elderly.

Most of these paintings have grown out of sketches, many have been scribbles made in the field – little profiles of land, shapes of waves at sea, attitudes of birds, animals and fish about their business, all on scruffy bits of paper and all, as drawings, ghastly.

One of the things I envy most about nearly every wildlife painter I know is that their field sketchbooks are lovely things to look at. There is diligent observation here, distilled and delineated with precision, brevity and infinite skill. I admire them without reserve. This goes for young contemporary artists as much as the masters of yesterday, some of whose sketches were much more exciting than their finished work.

My own notes are gauche, inept and, worst of all, unlovely in themselves. They mean something only to me and their one merit is to be a catalyst in the planning of a picture which might provide, for me anyway, a deeper fulfilment.

There are excuses, but only lame ones. A lot of this work is done in small ships or under conditions where substandard drawing was all one could reasonably expect and they should be judged accordingly. But when it comes to the crunch I have to make my own assessment and I find the field notes sadly wanting.

This leads to the inevitable question, What is the role of photography in all this?

The answer is that the connection is a very close one. Both are two dimensional renderings of three dimensional realities. They seek the same subjects and are instigated by a similar degree of devotion. Finally they are judged by similar yardsticks if only because they are both visual images. To a wildlife painter though, photographs can be the knell of doom as easily as objects of enormous assistance.

To begin with, the slavish copying of a photograph of a living animal is invariably a disaster, and for very good reasons. A photograph is no more than an accurate record of a split second of action. All it is saying is that the position depicted was achieved in that split second and may therefore be regarded as a physical possibility. Because of

this, it may well have considerable anatomical interest. But what it is not telling you is what led up to the split second and how the continuity developed thereafter. It is a happening in space, out of context and without explanation. If it were a single frame in a film, all would be made clear, and this really makes the point, because a film as we watch it is a living sequence. To sketch from a running film would be as valid as sketching from life itself.

The greatest value a camera can offer, I think, is a reference for simple details of markings. The surface map it records must be accurate, no matter what the attitude of the animal. But the attitude itself, unless it is one of minimal action, or better still, one of repose, is more than likely to mislead.

I have a camera and with it take extremely bad pictures, usually because I have overlooked a quite elementary detail like setting the correct

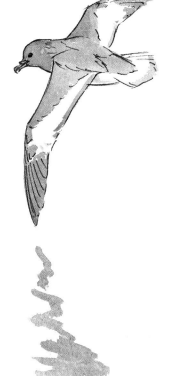

ANTARCTIC PETREL

ASA for the film inside or omitting to renew its tired little battery. As a result of this I have more than once returned from three or even four months at sea with twenty or so rolls of entirely black film. As Dennis Norden put it, "I fear I am to technology what Marconi was to hairdressing".

There were usually some, however, that did come out and helped me a lot. Generally the greatest value of a photograph is when you have been painting a picture out of doors and the light is just right and a photograph is taken. Because the whole scene has been looked at and lived in, the photogragh can be interpreted with sympathy and understanding. It has become more of a reminder than a record. I have noticed too that while painting a picture of a subject of special interest, looking at a number of allied photographs, even though in no way representing the subject itself, can rekindle memories of the whole atmosphere and revitalize the motivation to paint.

There is certainly a liaison between the camera and the brush and levels for comparison, but it has to be said that a colour photograph is not the zenith of artistic expression but a clever chemical facsimile of life. Seeking to imitate its qualitites has little to do with a serious attempt to paint reality.

Having confessed that so many of my best friends are water colourists, I can add that just as many are photographers, but with them I am conscious of holding a few aces. They can after all record only what nature has laid

out, while with Olympian facility, a painter can reorganize or transplant just anything if the painting would seem to benefit, and invariably it does.

The most understandable of questions, and probably the most unanswerable, is "how long does a picture take?"

Every painting is a separate entity. If the work gets off on the right foot it is amazing what can happen in a day, even on a very large canvas. The whole concept can be laid down solid with seemingly no scope for subsequent alteration, nor need for surface embellishment. Yet weeks could pass before the thing is seen as acceptable enough for signature. The delay would have been a result of some nagging, elusive criticism that never quite defined itself. When this happens I find it helps to turn the picture to the wall and forget it. Months later it could be suddenly surprised by the light of day. The discordant whatever-it-was would be immediately pinned down. The time elapsed then proves just as valuable a factor as time with a brush in hand. It is easy to get close enough to something to be oblivious of its faults, and that is the time when it becomes necessary to erase the memory, so that the picture can be confronted once more with a new eye and a fresh appraisal. Half an hour's actual brushwork might then be all that was needed to conclude a work that had taken three months to "mature" and the hope of answering how long did it take is gone for ever. By the same token, the three months in

visual exile could be avoided if a good friend, or a wife, walked into the studio and immediately pointed out the mistakes as soon as they happen; such windfalls should be instantly grasped. Picasso once said that a painter should eliminate all "happy accidents" from his work – it is a philosophy that totally escaped me. If it were not for the bounty of an occasional happy accident, I would find little reward at the easel.

The execution of detail for its own sake never much appealed to me, though I admire it in the work of others. That it can be achieved in oils was abundantly proved by Canaletto, so the choice of medium is not the real reason and neither is idleness. I am just not all that interested in the fiddle-de-dee on the surface. The underlying dynamism of living things and what can only be described as their character is much more intriguing. Detail is something that in practice you seldom see. If you feel obliged to put it in because you know it is there, the true conviction of reality is generally the first casualty. Detail is always there for the looking on a stuffed specimen, combined generally with the anatomical maladjustments of taxidermy and the fading of the colours, but seldom on a live one.

The dodging of detail of course can be seen as a cop-out, but there are convincing reasons to justify it. Some years ago, I was walking round the Piper Aircraft Corporation in Pennsylvania. Hanging in big letters in some of the design

offices were salutary proverbs to sharpen the mind.

"Simplicate" said one "and add more lightness". Another one read: "What don't go into an airplane, don't cause no trouble". There is no denying the truth in that.

If you put no details, you have side-stepped the criticisms they could and probably would attract. Moreover you have avoided the mute statement that this is a completely finished work down to the last greenfly on the last stem of grass, an assertion that will always prompt the reponse from somebody, somewhere, of mounting a nit-picking quest for the minutest error – and all because you yourself have unconsciously invited it. There is little justice, I know.

Once or twice this reputation for a mildly slap-happy approach to matters of detail has caused me to be cautioned. One occasion was over a cover for a magazine renowned for its ornithological accuracy. The picture was to be of Gannets.

". . . and you had better find how many tail feathers there are in a Gannet and give it the right number – or somebody will have a seizure," I was told on the telephone.

ADÉLIE PENGUINS

It had been a doom-laden voice which meant what it said, so I went to the zoo where a couple of Gannets were convalescing after an oil spill. I went to the Natural History Museum and examined a drawer full of camphor-smelling Gannet skins that must have been there since the Relief of Mafeking. I delved through a host of textbooks and finally learnt that the official number was twelve. But from an examination of photographs and later of real wild Gannets again, I discovered that the number could be anything from twelve to three, according to the progress of moult in the individual, or its current state of dishevelment. Nobody wants to paint a wreck so I settled for what looked like a round dozen, but tried to paint it like a Gannet's tail, obviously endowed with a wholesome display of feathers

somewhere within prescribed limits but not all that easy to count as separate quills.

This was a warning well worth heeding. I believe that representative painters should try to get things right by nature. Exaggerate by all means, even distort for this may achieve a closer likeness through the process of caricature, but there can be no merit in gratuitous mistakes when keeping faith with reality simply calls for a little more observation or a little more research. The broad concept of atmosphere of a painting will not be altered. There will be just the added satisfaction of knowing that it also records the truth and reduces that level of seizure risk.

"And are you ever satisfied . . ?" is the final question and positively the easiest. The answer is No.

I cannot imagine what a painter would do if he were ever "satisfied" with his work. The spiritual injection that goes with a continuing challenge would fizz out like a dying balloon, and nothing would lie ahead but a ghastly self-nourishing slough of apathy.

Approval is something else. A painter can surely allow himself the luxury of being *pleased* with a picture from time to time. Encouragement is a valuable plant and a little fertilizer on its roots can be no bad thing.

So each new unsullied white rectangle on the easel should be regarded as the great work of a lifetime in embryo, the ultimate masterpiece, but if it ever were and its reward the gift of total satisfaction for the painter, then in my view it should be his last picture of all.

THE PAINTINGS

"First Ice"

There are two routine entries that go into the log-books of ships heading south. Both tend to be recorded with special interest and in some detail and both tend to be posted on the notice board.

One is the crossing of the Antarctic Convergence; a circumpolar ring of surprisingly constant position, where cold, north-going surface waters from the Continent itself slide beneath warmer layers of the sub-Antarctic ocean. It is a narrow belt and an important one in terms of planktonic life and so to all the larger elements of the food-chain thereafter. It is sharply defined. The character of the water changes here, and with it the first real chill in the air as thermometers drop several degrees in perhaps an hour of southward sailing.

Once through the Convergence, though there may be a long way to go before a sight of land, the threshold of the true Antarctic has been crossed. The Convergence is a natural proclamation of boundary; a statement of exactly how far out, into a vast and turbulent surrounding sea, the frozen presence of Antarctica may be felt.

The other log-book entry would be "First Ice".

In ecological terms it is unimportant. But visually – and emotionally too – this is the one that counts. It brings all hands on deck. It is treated to a far more thorough inspection than any other piece of ice will be deemed to merit from now on, for such is the prize of priority.

Since long before *Titanic*, icebergs at sea held a fearful significance. Yet because they are synonymous with high latitudes, the first to appear can amount to a good half the total visual reward of a voyage. First ice may sneak by as no more than a radar picture in the darkness, to be noted and timed by a vigilant watch officer; or it could come clear like this, in the middle of the morning. It might be two or three little ones or a single flat-topped monstrous thing the size of the Isle of Wight or the state of Rhode Island.

Furthermore, it could present itself either side of the Convergence because an iceberg, despite its grandeur, its individuality of size and shape, is just another loose item floating free. Like driftwood, like an empty bottle, it goes where the winds and the currents take it.

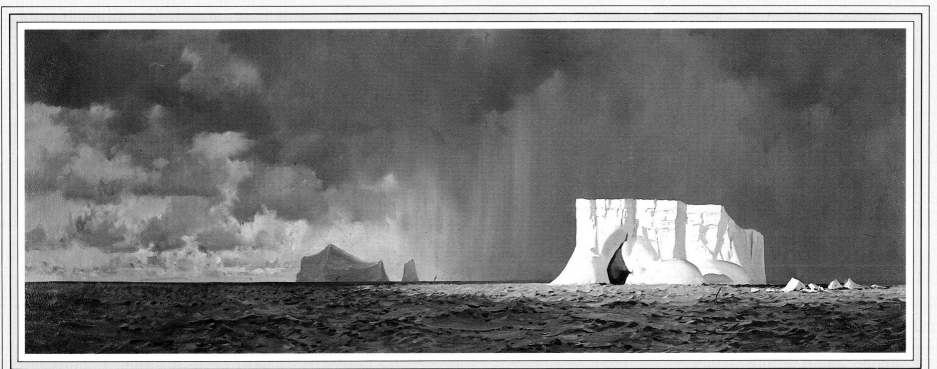

18″ × 48″

26

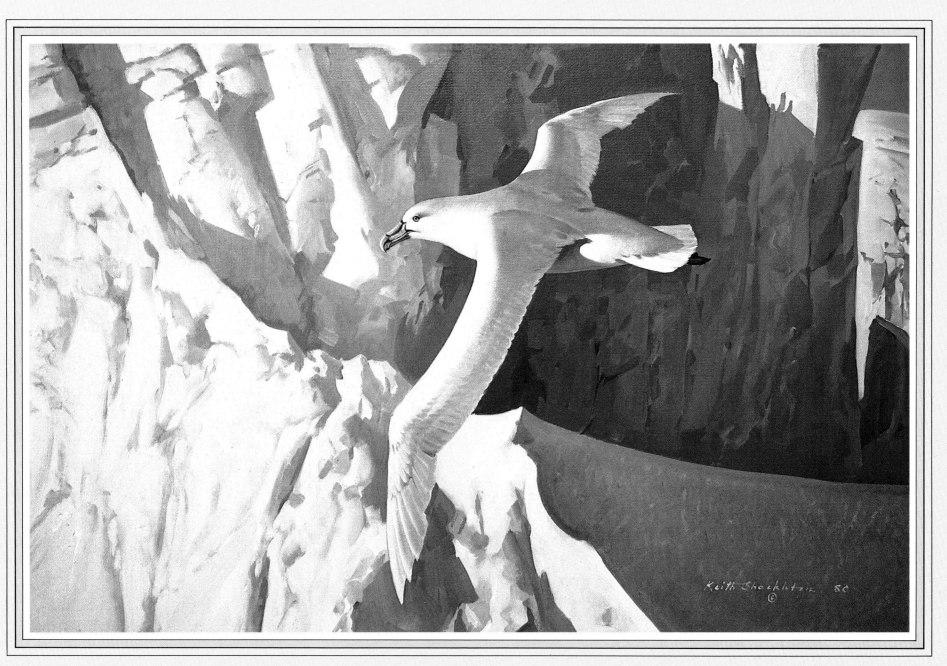

24″ × 36″

ICE BIRD

This must be as simple a concept as can be devised. The whole picture is made up of only two things – ice and bird.

The thought that came first while watching a Giant Petrel glide along the cliff-like face of an ice shelf was that the shadows cast on and by ice are cold in colour, but on the bird they fell warmer, even though the warmth has nothing to do with the temperature of a living thing. I wanted to use this contrast as a means of illustrating a striking dichotomy of character as well as shape. Making the bird stand out by any means at all would help the movement of a living creature against an entirely static background that can only be seen as mineral.

It is probably exaggerated. Exaggeration can be no bad thing to try, by the same token that a caricature can often make for a stronger likeness than carefully measured accuracy.

The name "Ice Bird" was one used by the old whalers for this entirely white phase of the Giant Petrel or Giant Fulmar. These birds, which even by the most charitable of yardsticks, are pretty hideous, were more normally referred to as "Nellies" (for reasons I never knew) or "Stinkers" (with clear justification). They are a polymorphic species.

Nellies or Stinkers abound in plenty and right round the world in latitudes between the Tropic of Capricorn and the northern limits of Antarctic ice. On the wing they are gorgeous and have been described as a poor man's albatross: close to, they are not. But the interesting thing is that their polymorphism throws up individuals from almost black through a variety of browns, greys, khaki and sludge-coloured intermediates, to a pristine white. This last elite version is the Ice Bird and it is the only really large, all-white seabird in the southern ocean, or come to think of it, any other ocean.

If one is close enough to an Ice Bird however, which is very possible because they allow you to sit beside them while they incubate their single egg and brood their chick, you will notice two things. The first is that they have the palest blue eyes, bereft of both warmth and expression; the other that they are generally peppered with erratic grey-black spots like a feathered version of a dalmatian, savagely laundered. To my mind this is a pity, it mars the overall white cleanliness of the bird, so I felt justified in singling out a real white one, a perfect Ice-Nelly, rare though they may be, and used him (or her) for the model.

Pintado Flight Pattern – Deception Island

Daption capense to science, Pintado or Painted Petrel to maritime bird watchers, but to the old sailors it was always Cape Pigeon, a sure precursor of latitudes south.

Their range extends from south of Capricorn into the ice and right around the world, but like so many of these pelagic, tube-nosed birds, they follow the cold north-going Benguela current off the Atlantic coast of Africa and the Humboldt off Pacific South America, and stay with these rich feeding grounds as far as the Equator and even beyond.

Their build-up as escorts to south-bound ships is a heartwarming sight, and with the sun going round in the northern sky, they are well lit under the taffrail, their shadows sharp over the white foam of the wake. They are solid, dynamic little birds with great dash in their flight and their early confusion with pigeons is readily understood.

In their breeding, as well as their range, they have a circumpolar spread and often occur in vast numbers on well-scattered islands of the sub-Antarctic. Such an island is Deception in the South Shetlands, an island as remarkable in aspect as it is in its short history of human encounter.

It was born out of a great volcanic upheaval. Today it is a caldera, inundated by the sea. Its shape is that of a horseshoe all but forged into a ring. The narrow passage remaining – Neptune's bellows – faces to the southeast and is the only entrance to Port Foster, one enormous anchorage completely surrounded by land.

Though the original eruption is long since passed, Deception is still on the back burner. Fumaroles and dense clouds of steam rise from cinder beaches that vary from warm to boiling. Major eruptions regularly occur to rearrange the landscape. Two scientific bases and a whaling station of considerable size have been totally destroyed in recent years.

The result is a sterile moon landscape of a place, affording a perfect footing for nesting birds whose food supply is in the ocean, and here seemed the perfect setting for Pintados in flight.

The smart, pied checkerboard pattern of each bird is a cameo of the pattern of a whole flock. It offers also an echo of the snow, rock and cinder patchwork that characterizes the entire island.

Deception's minerals hold all the fiery colours of a painted desert; heat and incandescence have given them a lasting warmth as the kiln does to bricks and flowerpots, and there is no better complement to black and white.

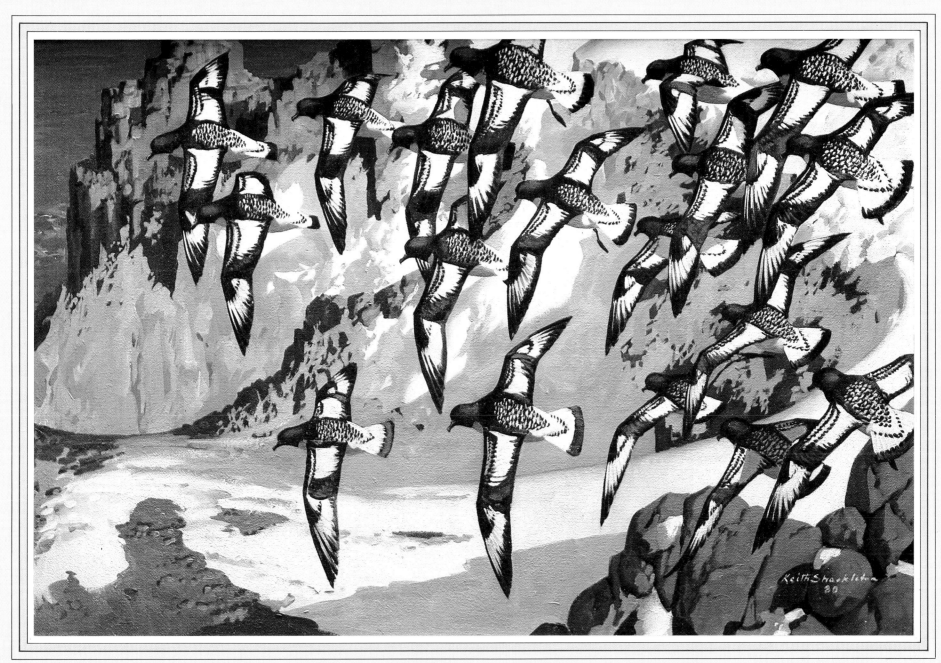

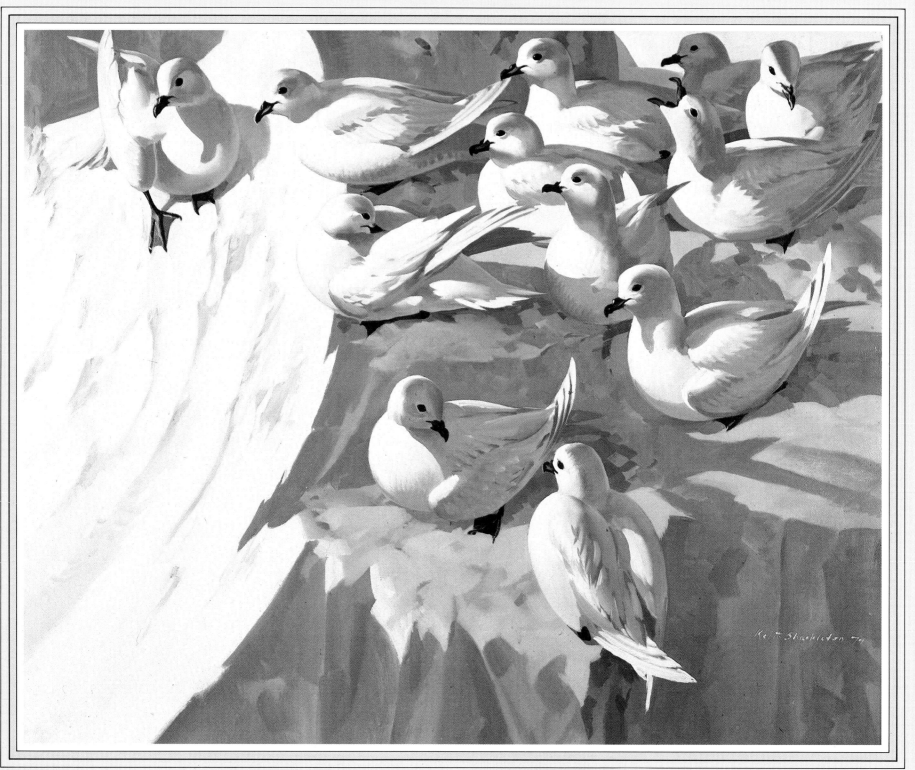

24" × 30"

ICE, SNOW AND SNOW PETRELS

There is something enormously pleasing about an animal that, when looked at in isolation, seems to tell you everything you want to know about where it belongs. Nothing could be more redolent of an autumn covert than a Woodcock; of the moors than the tweedy, heather-mixture patterns of a Red Grouse; of striated forest bark than the plumage of a Tawny Owl – or of Antarctica than a Snow Petrel.

Parallel evolution in the Arctic has achieved a northern lookalike in the Ivory Gull. It is totally unrelated to the Snow Petrel but similar in aspect, inhabiting lookalike places, flying with a lookalike flight, but not quite achieving the same oneness that makes every Snow Petrel a little chip off the frozen environment that moulded it.

A Snow Petrel's plumage, every feather of it, is pure white. Its eyes and bill are black and shiny as coal. The legs and paddles are black too, but may be visually overlooked because on the wing these are tucked up out of sight, and at rest are sat upon. So the overall effect of the black intrusion is that of a minute granite nunatak peeping modestly out of a pristine snowfield.

A hundred Snow Petrels can be sat on the tip of an iceberg and remain unseen, or more accurately, unnoticed – taken as a mere extension of the irregular mass. At the last moment they will take to the wing as one, and anyone watching the event will be startled at the sudden explosion of quiescent ice into life. It is then that they become snowflakes on the move, a blizzard of wings and an object of transcending beauty.

Large numbers like that are not the usual – one thinks of them more as loners, in ones, twos or threes, or little groupings like this one in the picture. As if they felt a positive need for a background to match, they seem to keep within the realm of the ice. As soon as the clatter and scrape of pack and brash ice is heard against the ship's hull, when the engine note changes to back off and drive ahead again with a shuddering halt and a steadier continuing pace, you may be sure that there will be Snow Petrels around to greet this rare invasion into their own special domain.

It is a bird that fascinates me. As an Antarctic emblem, it has as much validity as a penguin, but the power of flight takes it into stranger places. I have sketched Snow Petrels sitting quietly on their nests in the South Orkneys and the South Sandwich Islands, and here their pure whiteness catches the eye in crevices in the rock and against the warm, subtle colours of moss and lichen. But inaccessible, overhanging crags and the forbidding screes of the Antarctic continent, far inland, are their nesting grounds too; and it may well be that Snow Petrels breed closer to the South Pole than any other bird. Looking the way they do, it would not only seem likely, but wholly appropriate.

FIVE WEDDELL SEALS

There is no seal that looks more like a seal than a Weddell Seal.

All the essential raw material of popular sealhood has been assembled here. Sleek and fat, large-eyed, beautifully marked and tastefully whiskered, but Weddells have a background of mystery in their lives that provides an extra edge to goad one's interest. In people it is the kind of secret fascination that goes with an eye patch, a slight limp or a parrot on the shoulder. In the seals' case it derives from their incredibly deep and long-sustained dives under the ice into a dark and awesome submarine world, so intimate to them yet so seemingly distant from their relaxed, easily-approached siestas in the open air.

So much for the seals themselves. My hope in painting them, similar to so many other group compositions, was to achieve a following line that would run through the picture. It was something that the Old Masters sought and achieved with enormous success, and is explained by a simple property of the human eye.

When we look at a picture, or anything else for that matter, we are actually focusing on just one point at any one moment. This focus of attention is flicked all over the subject of our gaze. The point of acute interest is forever on the move, returning now and then to areas of special interest and lingering there, but all the time there is an awareness, albeit out of focus, of the general imagery surrounding it.

An extreme example would be a very long picture, so long that one's appraisal of one end could not include any consciousness of the other. As the eye passes along therefore, following different attitudes of the subjects, the picture could well begin to offer an impression of "moving" like a film.

A carefully planned composition, with subjects ranged in attitudes complementary to their neighbours, will set the eye moving, and hopefully the picture with it. In this case of the Weddell Seals, it is not just the lines of their bodily position in the picture. Odd animals are clearly looking at something themselves; the reaction is to follow their line of gaze oneself and so continue this circular appraisal of the whole group.

"Movement" however, may be overstating things. There must be more appropriate words in the vocabulary of art to describe a group of Weddell Seals – at rest.

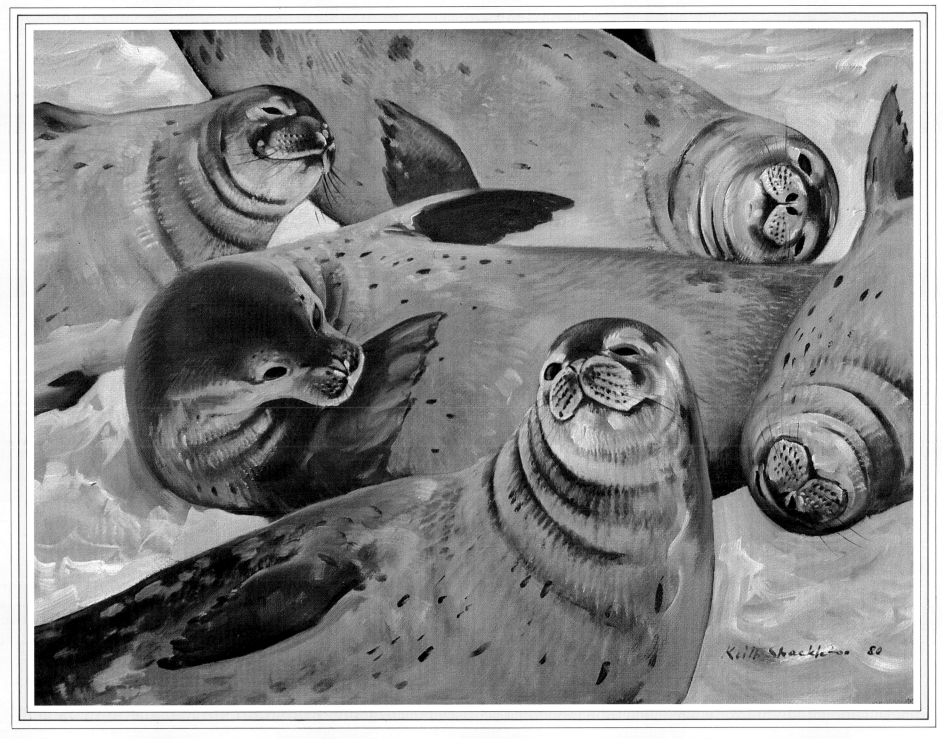

18″ × 24″

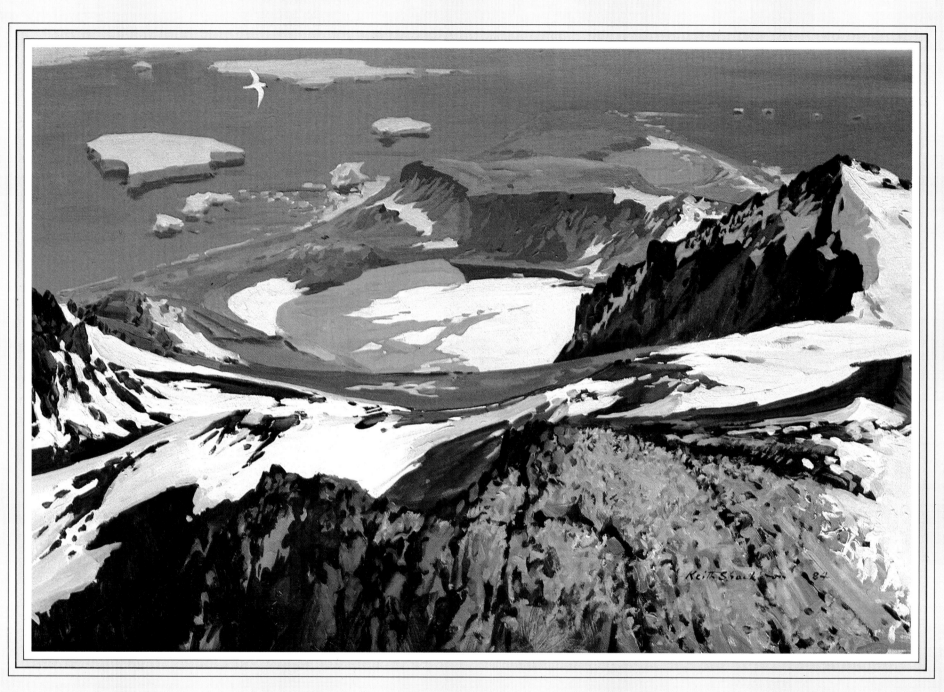

34

24" × 36"

VIEW FROM THE SUMMIT – PAULET ISLAND

It had been a frustrating sort of climb.

To put it in scale, the extinct volcanic cone of Paulet is barely 1,200 feet, but the top half of it is entirely cinders and fine volcanic ash of every colour, with rich brick red and a deep violet predominant. Like sugar in a bowl, the cinders have slid to an angle of repose of around 45° with the same straight profile of any scree; but being of such light and easily shifted material, the slightest interference sets it sliding again, and every full step up is reduced by two-thirds in a wasted backslide.

Paulet is in the northwestern end of the Weddell Sea, renowned for unpredictable ice conditions and the loss of ships – not the least being Sir Ernest Shackleton's *Endurance* in 1915. The island however gained its historic significance first through its name, bestowed by Sir James Clarke Ross in 1842 for an old shipmate, Lord George Paulet RN, but more recently in 1903 when Carl Larsen, Master of the *Antarctic* and his crew, came here over the ice after their ship had been crushed and sunk on Otto Nordenskjöld's expedition.

That narrow neck of land in the picture, immediately below the inevitable Snow Petrel and between the old crater lake and the sea, was where they overwintered in a stone hut they built themselves with sails for a roof. The loose stone walls of the hut remain, littered with the bits and pieces of human occupation, stubs of candles, old boots, rope ends, broken cutlery, even the grave of one of their company who died, and the whole scene is inundated by nesting penguins. In my picture all this is too far away to see and there can be no hint of the teeming birds below.

All the lower areas are under penguins, wall to wall, and up the steeper bluffs as well. Hundreds of Blue-eyed Shags nest on that escarpment above the lower crater, above them in the rock screes are Snow Petrels and Sheathbills, and above those, Skuas, fiercely defending their territories.

As you climb, the birds thin out. Here and there the cinder slide is checked and retained by high vertical buttresses of rock, giving a lee from the wind for Antarctic Terns to nest, and a somewhat slower pace to the climb until the rocks are overcome. Then these polychromatic cinders all the way to the top; sparse drifts of snow and fields of the lovely grey-green lichen, *Usnea.*

Returning is something else; by standing with outstretched arms like an impassioned evangelist, it is possible to balance and glissade down the incline without moving a foot, skiing without skis, the cinder carpet and the boots gliding together. One must be mindful of stopping before the first buttress drop-off, but it was all a lot quicker than coming up, and the view from the summit well worth it.

ANTARCTIC TERNS DOWN THE DANCO COAST

There are some landscapes of such shattering majesty they literally take the breath away. Most, I find, concern clouds or mountains – or both – either the view down from above or the view up from below. There is hardly anywhere on the whole of Antarctica's Danco Coast that could not present a perfect illustration of what I mean.

As often as not it lies under a duvet of cloud for days on end, clouds with a base of little more than 50 feet. A ship will tread her way through the ice with only the radar telling what the eyes are missing higher up. Then a wind, unfelt at sea-level, will shred the mantle apart like a violent unveiling of some mammoth piece of sculpture, and the sun pours through.

It can happen surprisingly quickly, and its greatest impact is the angle at which the peaks appear. The vision presents itself so nearly overhead that it is hard to believe they can be the logical upward extension of the visible shoreline, and not some tricky image reflected from elsewhere and about to dissolve as quickly as it came.

Antarctic Terns are very much a part of this sort of scene. This is their coast. This is where they breed and odd ones are following the channels all the time, resting on the floes, hunting in the leads until the first frazzle-ice of winter closes off their summer range. Only then will they begin to move north with their newly flying young, to maintain contact with a source of food only open water can provide.

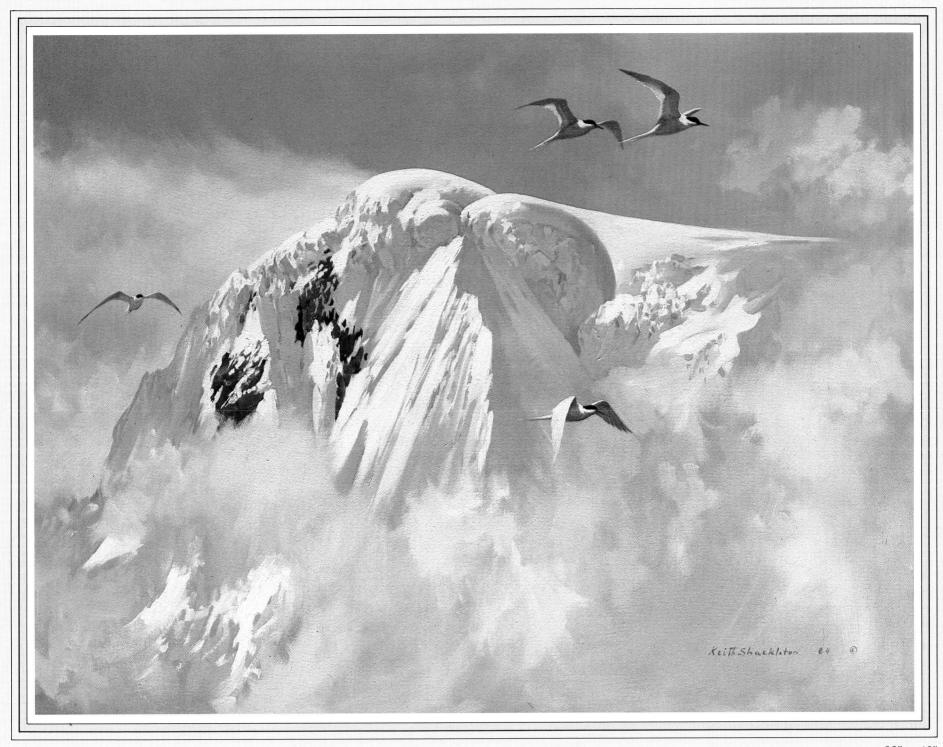

Keith Shackleton 84 ©

30" × 40"

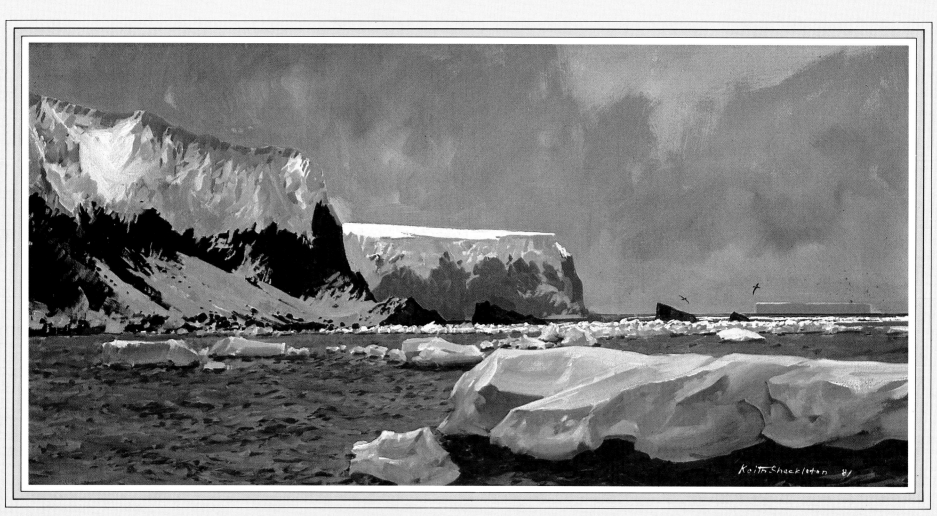

18″ × 36″

BOUVET ISLAND

It is doubtful if any sizeable island, except perhaps a few of those immediately adjacent to the continent of Antarctica itself, has felt the tread of fewer human feet than Bouvet.

To me it is a magical place. It always was on paper, and it is now more so in actual memory. Recognizing that man is the only animal that has ever proved capable of destroying whole environments, anywhere that is genuinely *uninha-bited* enjoys a flying start in my esteem.

The attraction such islands exert is the more extraordinary because it is in a way negative. Their whole appeal is founded not on something they have, but something they lack. The absurd thing is that having landed on such islands, any evidence of earlier human occupancy – a ruined hut, a grave, a tin kettle – immediately strikes a chord of fellow feeling and leaves the place with an even lonelier feel than it had before.

Statistically, Bouvet Island is the most isolated piece of land on the earth's surface. "Isolated" in this context is purely geographical and simply means furthest from any other piece of land. Easter Island in the South Pacific could be a good contender, but for the presence of Sala y Gomez only a couple of hundred miles away. Bouvet, between South Africa and the Queen Maud Land coast of Antarctica, is over one thousand miles from the nearest point of dry land.

Aesthetically it is little different from many other islands of the southern ocean. Its appeal to me as a subject lay more in sentiment than anything else. A stone from its unforgiving beach became a treasure. I wanted to paint it as a reminder of a great day and a very special place. Four of us stood there, soaked to the skin, the two boats neatly beached, and looked around. Stones and little icefalls cascaded from the cliffs behind, the beach was steep-to, with slithering shingle and lumps of brash ice buffeting in the surf. Fur seals had hauled out on a little point called Cape Lollo where the wreckage of an old ship's boat from God knows where had found its resting place.

When very deeply moved by anything, we often take refuge in childish hilarity and lightheadedness, and the thought which ran through my mind was that here at last was a place where one could be confident, beyond any reasonable doubt, that nobody would be waiting to sell life insurance.

WINDY AFTERNOON IN THE WEDDELL SEA

Water is the most visually versatile stuff on this planet. In one form or another, to a greater or lesser degree, it is everywhere, and its subject possibilities are endless.

From ice with the consistency of rock to the buoyant clouds above, it will adopt any form and it would be hard to decide whether solid, liquid or vapour commanded the widest repertoire of possibilities for a painter. The geometric crystalline structures in snowflakes alone would fill a book. A splendid *Illustrated Glossary of Snow and Ice* has been published by the Scott Polar Research Institute, to present some of the more usual manifestations of frozen water as it develops in response to conditions around it. In some ways it is like a meteorology handbook dealing with the opposite end of the water range, explaining and naming shapes of clouds and analysing what caused them and what they predict in the way of weather to come.

So in one or more of its manifestations water finds its way into many pictures of the outdoors, and this one is no exception. It has however concentrated rather heavily on the two extremes, and all but omitted the more familiar form of water as a liquid, with waves on it.

This scene is very typical of the Weddell Sea where it touches upon the northern extreme of the Antarctic Peninsula. The influence of liquid water is certainly there, but in the shape of remorseless ocean currents circulating clockwise to concentrate any available ice in whatever form into an unbelievable polyglot jam. The jam itself is further complicated by fierce catabatic winds from the high ground of the Trinity peninsula, maintaining a constant conflict between ice that is controlled by surface wind, and deeper formations – tabular bergs from the ice shelves to the south – that are pushed from deep down by forces far greater.

Before long in such conditions, open water is gone, everything is filled with ice to the rocky shore. Shredded cloud is whipped along by the same wind that lifts snow off the pack ice in plumes and williwars, and further confuses the line of demarcation between sea and land.

Parka hoods go up in deference to this sort of weather and the chill factors it brings. Even the penguins go in for some heat husbandry and transform themselves into little fat jugs instead of the slim and shapely things they can be. And it is something of a holiday for a painter who loves water but suddenly finds so much of his favourite subject has been "architect designed".

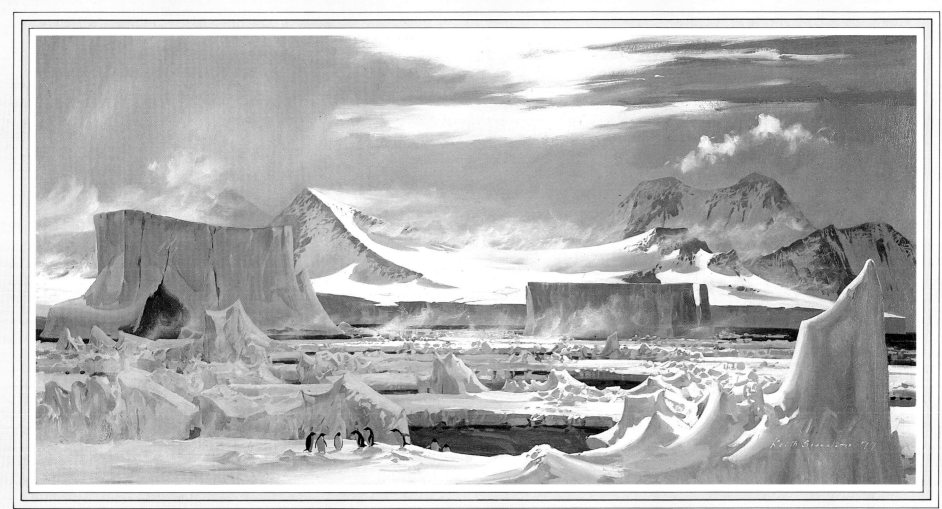

24″ × 48″

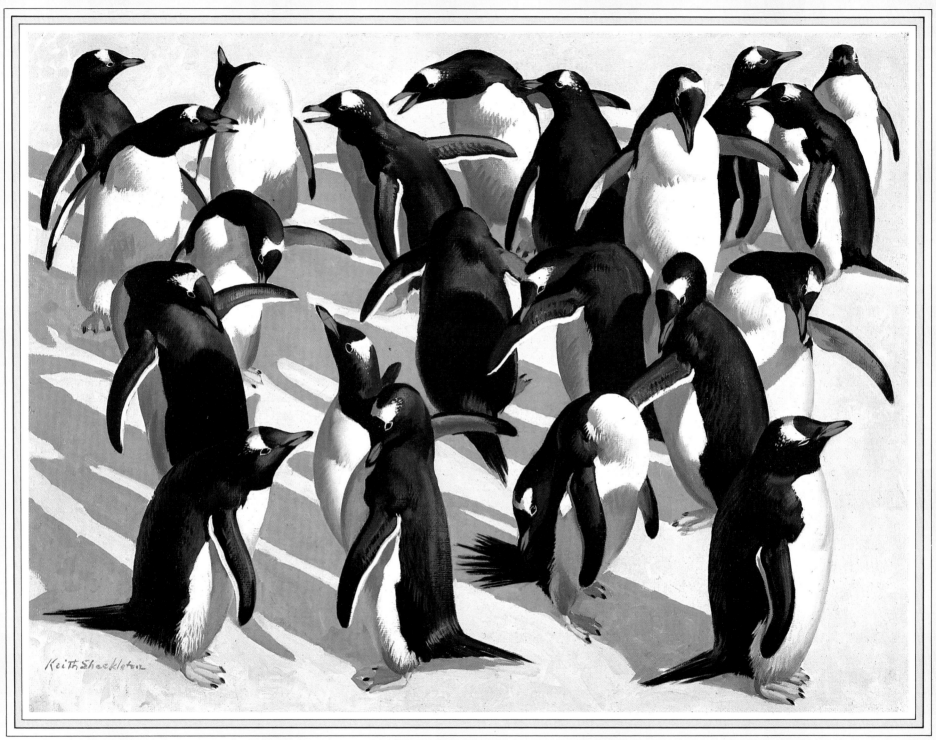

42

18″ × 24″

GENTOO PENGUINS

My old Art Teacher at school used to talk a lot about "composition".

Because he said the word in that mellifluous way more commonly used by the clergy, he managed to conjure up in my mind an exercise laced with portent, less artistic perhaps than deeply religious. "Next term we will do a – Composition." And so enthralled were we all at the prospect of getting stuck into this composition, a few of us might have even foregone the intervening holidays.

There are several pictures in this collection that might reasonably have met his requirements for "composition" status. Anything which involved groups of almost any subject matter, disposed in some attempt at harmony, was a "composition". A still life by its very arrangement was a composition too, but his interpretation, in the context of his promised exercise for the following term, was that it had to be imaginary. A lemon, a bottle and a stuffed Guillemot assembled on a gingham table-cloth was not, on this occasion, the challenge he had in mind. We must draw from life, then "compose" our drawings and develop them into a final great and glorious gesture in paint.

I thought about him a lot while planning this picture from a book-full of attitude sketches, which I sifted through and put together, trying to create little bits of interplay in line, shape and activity that would end up in some cohesive whole. I tried for the hundredth time to recall some of the other pearls he had tossed to us and cursed myself all over again for past inattention. I am sure I was not alone. It is a wise child that appreciates, at the time, his good fortune to be in the presence of genius.

"Next term we will do a – Composition" actually ran through my mind while I was sitting on a rock at a place called Waterboat Point, making the original field sketches in a blizzard. Gentoo Penguins were all around me in every attitude. Oblivious to the weather, they were simply getting on with the task of being penguins. I have always loved Gentoos. They are easier to draw than some of the others, they seem to hold a pose a little longer and they have more helpful markings and colour accents to consolidate the drawing. They also have a nicer nature than most.

Now it is the habit of penguins, during their courtship and pair-bonding repertoire, to present a stone to a mate as we ourselves might offer a little present in like circumstance. In a penguin colony the choice of gifts is limited, so a stone has become the accepted token for the love and admiration of one penguin for another . . .

Why I particularly remember this painting, is that in the course of the happy, if frozen-fingered, field work that led to it, a deeply emotional event took place. One of the penguins rose to its feet, waddled over the three feet that separated us, picked up a little black pebble and, with a beatific look I could only take for deep affection, laid it at my feet.

MOUNT EREBUS AND THE BARNE GLACIER

January 5th 1974 was a very special day. How many days in an average life, I wonder, fall into the category of unforgettable? There may be more than one would think and some would be more unforgettable than others. But the final count would not be enormous, even in a luckily "full" life, lived by someone conscious that there are now a great many days in there queuing up for assessment . . .

By any standards though, January 5th 1974 was special.

We had moored to "deadmen", iron pickets driven into the ice, off Cape Royds where Sir Ernest Shackleton built his hut for the *Nimrod* expedition of 1908. The plan was to walk over the sea ice to Cape Evans, the base camp of Scott's *Terra Nova* expedition which actually landed on the very same date, January 5th but in 1911, to begin the building of the hut from which that trek to the Pole began – to end in tragedy.

The weather was special too, an almost uninterrupted sun which still lingered a few degrees above the horizon at midnight, jumped fiercely back off the ice at noon. There was little wind and a visibility that seemed limitless. Out of all this loomed the Barne, and we walked around below its snout where ice ridges cut crazily across and hummocks had formed. Between them on the flatter areas, wind had built up *sastrugi*, often as beautifully formed as they can be irritating to sledgers.

Weddell Seals were keeping their breathing holes open and occasional penguins shared them, plopping in to return as if propelled by a pogo-stick to stand again, pristine and gleaming on the ice after a fresh bath. And the Barne, like the cliffs of Dover made in icing sugar, stood there over us and dominated the whole scene.

12,500-foot Mount Erebus, the symbolic epicentre of classic Antarctic exploration, looked just as close in the clarity of the air, her plume of steam trailing on the wind – an incongruous reminder of volcanic heat in a frozen land. And then we came to Scott's hut, clambered over the tide cracks against the shore and went inside . . .

I will not say more of this here beyond the fact that the picture became a print at the instigation of Lars-Eric Lindblad to make a contribution to the Antarctic wing of the Canterbury Museum in Christchurch, New Zealand. The New Zealand Antarctic Society have preserved these historic huts as they were when those men left them; with all their gear, their provisions, their magazines and much of their personal possessions intact; and this is how they remain today. It had been an experience of enormous spiritual reward.

Then we walked back to the ship – 14 miles of unbelievable beauty with a tangible, physical kind of joy in every step.

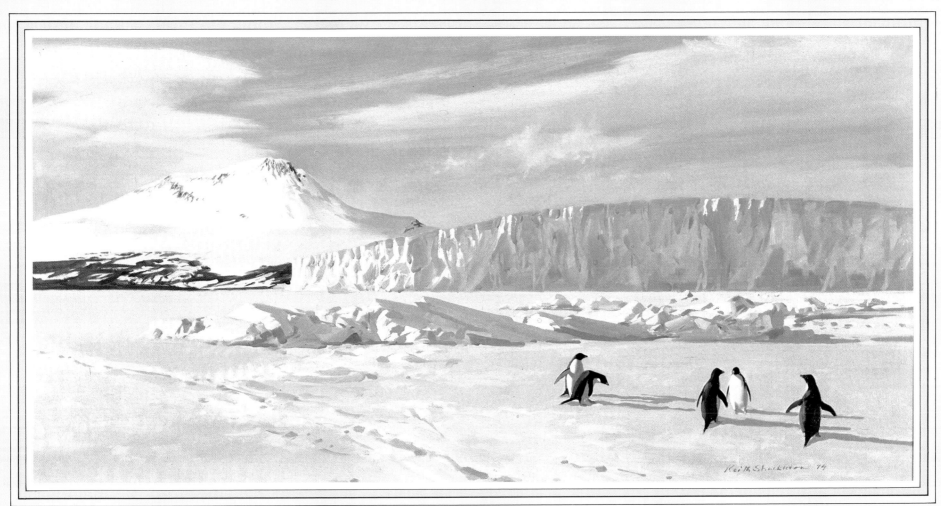

18″ × 36″

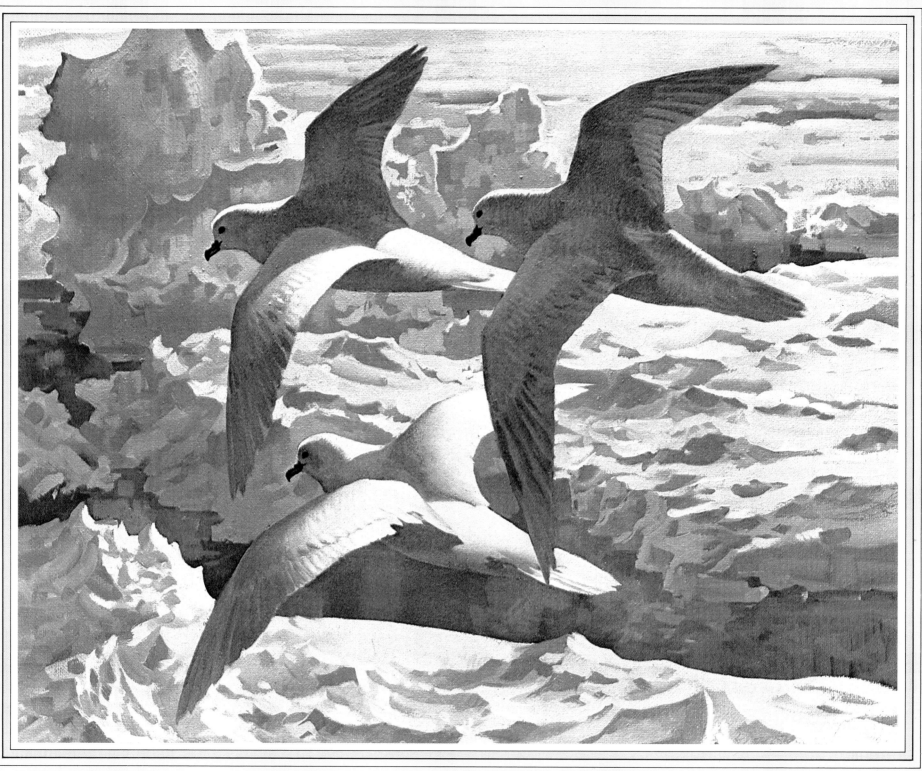

46

24″ × 30″

THREE SNOW PETRELS – A COMPOSITION IN WHITE

If something is white, you may be sure it is full of colour. White is the great absorber and reflector of everything around it. It echoes whatever is in range and becomes itself transformed.

I love white paint and buy the stuff in what can only be described as industrial quantities, the biggest tubes you can get, and I use it up like an addict. It is a strangely negative sort of appreciation though, because it is intrinsically an absence of colour just like black, and in the same way its appeal is for what it does in providing contrasts rather than what it is on its own account.

In the simplest terms of tone, white is pure light and black is pure darkness. You can paint nothing on a picture lighter than white, so it follows that there is no way of painting an actual source of illumination, only the effect of it when it falls on objects. Much can be achieved by contrasts to give the illusion of a light source, but its portrayal in its luminous reality is no more possible than rendering the setting sun with tomato ketchup.

These three Snow Petrels over the ice present a composition which is about as white as anything can be, but the sight of the real thing actually happening struck me for the thousandth time how dark can be a white object when it is obscuring light from beyond. The fact that it is opaque has much more relevance than its inherent whiteness, and the result in extreme cases can be to look almost black.

A friend of mine had a white Peacock and I learned a most interesting lesson from this bird. It strutted around in the manner of its kind among conventional Peacocks, which can be regarded, according to personal taste, as the most strikingly beautiful piece of colour mastery in all creation, or simply over the top in sheer vulgarity. The interesting thing though, was that because the colours are so arresting in themselves they seem to hold the eye there at the surface and allow it to go no further. The white bird on the other hand showed me for the first time what beautiful lines and structure go into a Peacock. I noticed the delicate fan-shaped tiara rising from the back of the head, the mantling wings, the huge spread tail trembling with captive sunshine, each quill sharply drawn, the lace work and the "eyes", every eye blind and white as everything else. Paradoxically, this male creature had the air of a gorgeous virgin bride on her way to the altar. I had the distinct impression that the white Peacock was the more beautiful because its very lack of colour had proclaimed the perfection of its frame.

If Snow Petrels lived in the jungles of Amazonas, among the toucans and macaws and the jewel-like humming birds; if, like the Peacock, they had electric blue head and breast, iridescent gold and green scapulas and tail and burnt sienna wings, would they I wonder, be lovelier than a pure white shape of supreme elegance, drawing from every colour around it?

ON THE GRAHAM COAST: SNOW PETREL

A warm-blooded, elusive living thing in a frozen environment of ice, snow, water and rock, is a cameo of Antarctica itself. Such a scene could present itself at a thousand and one different places along the continental coastline and most of the islands, making it typical enough to be symbolic.

Man played no part whatsoever in the moulding of this scene. Every shape and every line is the combined product of inexorable natural forces and the passage of time. It is a wilderness that is complete in every aspect and connotation of the word. Only a short walk on the moon might offer something more harsh, more unwelcoming.

I think a man would need to be a little short on imagination to feel no trace of awe and unease in such places, and a monumental conceit not to feel humbled by it. I know there are times when it can prove just too much and lead to homesickness for the gentler pleasures of walking through fallen leaves again in an English autumn, 7,000 miles away.

Be that as it may, the ingredients of beauty sometimes look strange in isolation. The legendary "eye of the beholder" often seems to be squinting down wonderfully scrambled lenses. Some may well be tinted with rose but I am sure that all are coloured by association. We find beauty, quite simply, in what we love. Some of us love what others find ugly and forbidding. Perhaps it is ugly because they just cannot see – or perhaps it is beautiful because it has been treated with a very personal form of alchemy.

But I can only speak for myself. Whether or not I should be on a psychiatrist's couch is academic – I just believe that landscape like this, savage, hostile and unremitting though it may be, by aesthetic standards, is still the most intrinsically beautiful landscape of all.

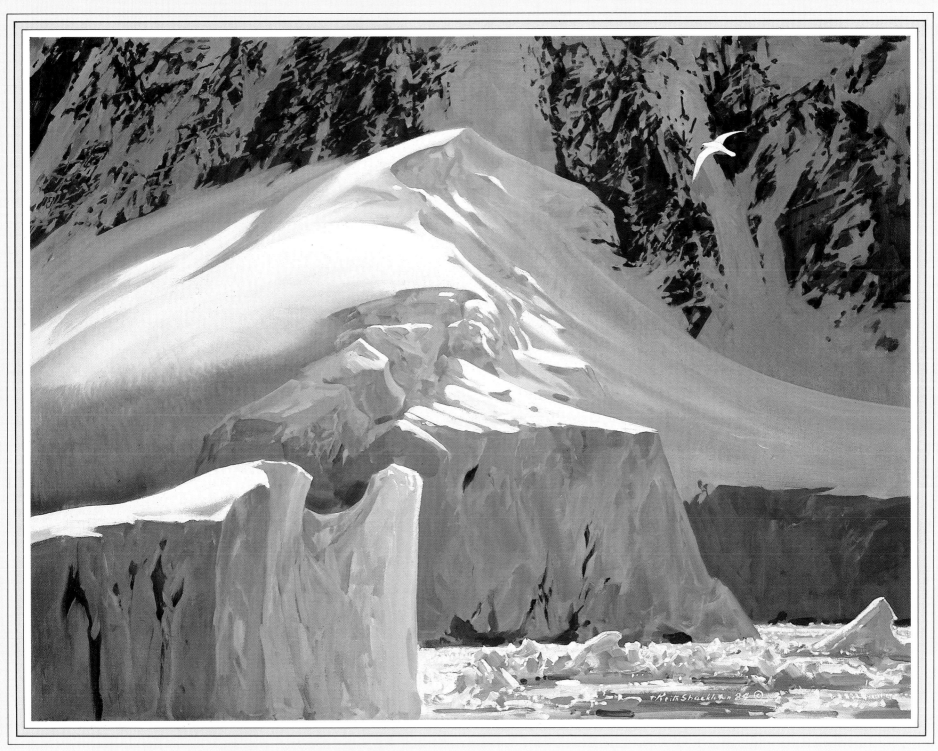

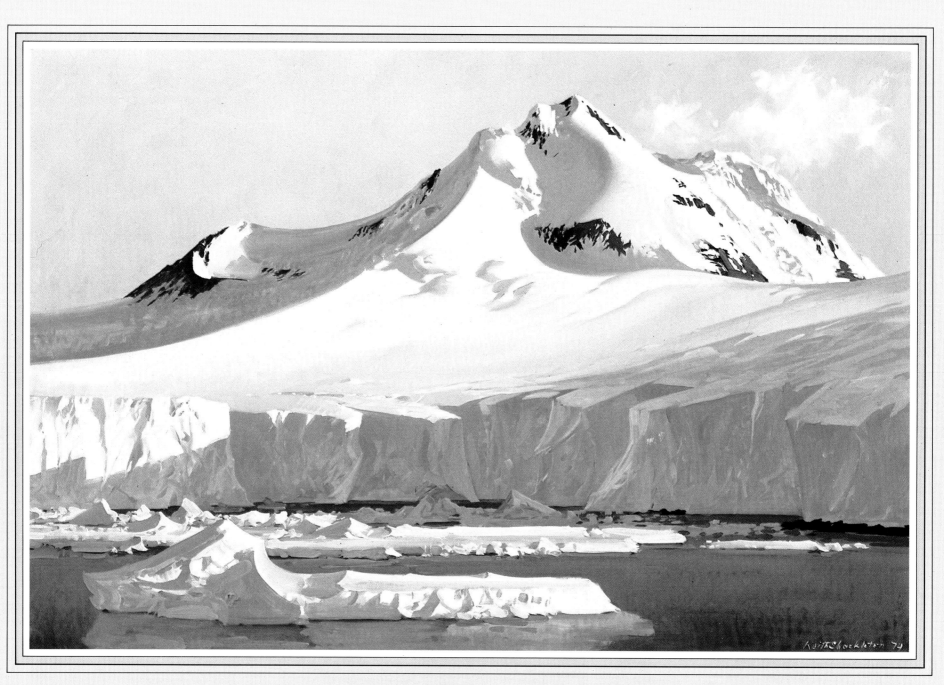

24″ × 36″

PORT LOCKROY

There are no sweeter curves in nature than those produced by wind. Sometimes the agency of water is involved, as with ripples on sandflats after the ebbing tide. Here it is wind alone, blowing across snow slopes, moulding and drifting them into subtle shapes in response to turbulence from interposed outcrops of solid rock.

Such lines are the stock-in-trade of creative naval architects, setting out a parabola with a flexible rule bent to conform with a series of predetermined points and linking them all together. The curving rule is bent against heavy lead weights laid out on the drawing board. The weights are shaped exactly like whales and the nose of each one marks a crucial point, while the flexibility of the rule allows them all to be united in a clean and fluid pencil line. When rule and whales are taken away, it looks like magic.

Successive lines finally determine the developed shape of a hull and there is generally a pleasing outcome in that if the shape looks right, it will be so. The eventual boat will be fast and stable, and slip through the water with a minimum of fuss.

It is the same with aeroplanes – airflow and waterflow have everything in common – an accurate model introduced into test tanks and wind tunnels will confirm ideas, suggest improvements and offer revelations as fascinating as they are helpful.

This is a picture of a natural wind tunnel. Nunataks thrusting through the drifting snow, set up eddies of endless persistence that scour out troughs and build up ramps, always with grace and simplicity of line, until the profile of this responsive surface has been moulded to offer minimum obstruction to the wind.

These upper snowfields present one of the special charms of Lockroy, and they are offset by the rough-hewn look of the coastal ice cliffs below. The effect is like those Rodin statues, smooth and finished and beautifully conceived but lying in stark contrast against the virgin rock from which the sculptor carved them.

Lockroy itself, despite first impressions, is a "port". It was once a favourite haven for whaling vessels, and its beaches became a graveyard of enormous bleached bones; but the conventional installations synonymous with the word "port" are absent. It won the distinction of this status entirely for its natural advantages. It is sheltered from wind and swell, has good holding ground and is served by channels whose tidal streams keep them clear of summer ice. It is a place in short, where a ship can drop her anchor and relax.

If this picture were to be treated to a sound track, part of it might be a distant wind reshaping drifted snow across the "harbour", overlaid perhaps by the drawn out rumble of an avalanche from the mountains along the spine of Graham-land. But from closer at hand, the dominant sound would be the incessant, garrulous chatter of Gentoo Penguins at the height of their breeding activity. This is the view from their rookery, and there is no way one may sketch this scene without acquiring penguin guano over the seat of the pants, and guano of Blue-eyed Shags as well!

WILDERNESS PATROL: HMS *ENDURANCE* AT HOPE BAY

52

. . . A vessel to excite pride and affection even from those who never served in her. Based at Stanley in the Falklands, she sailed these waters in a quiet, reassuring way, performing small and superbly executed services for all nations with scientific bases in the south – services like communications, provisioning and the delivery of mail in filthy conditions with her helicopters.

Then she was caught up in politics on an international level and finally, war; just another example of jingoistic aggression in the style of Adolf Hitler. The exploits forced on her then enhanced both her stature and her fan club. This picture was commissioned by Lord Buxton, and prints of it sold to aid the South Atlantic Fund.

The mountain is Mt Flora, a lovely scramble of a climb, littered with fossils; and beyond her bow, the Depot Glacier . . . But here I must confess to a habit of many painters – including Constable no less – of shifting the topography about to satisfy an aesthetic whim. Ethically I suppose it depends on whether you are setting out to paint a picture or provide a "record".

Be that as it may, I cannot see it as playing God to move a few billion tons of ice a few miles north, with my little hog-hair brush, if that is where I would like to see it. And another thing; it gives us folk this vital edge on the photographers without upsetting in any way the general atmosphere of the scene.

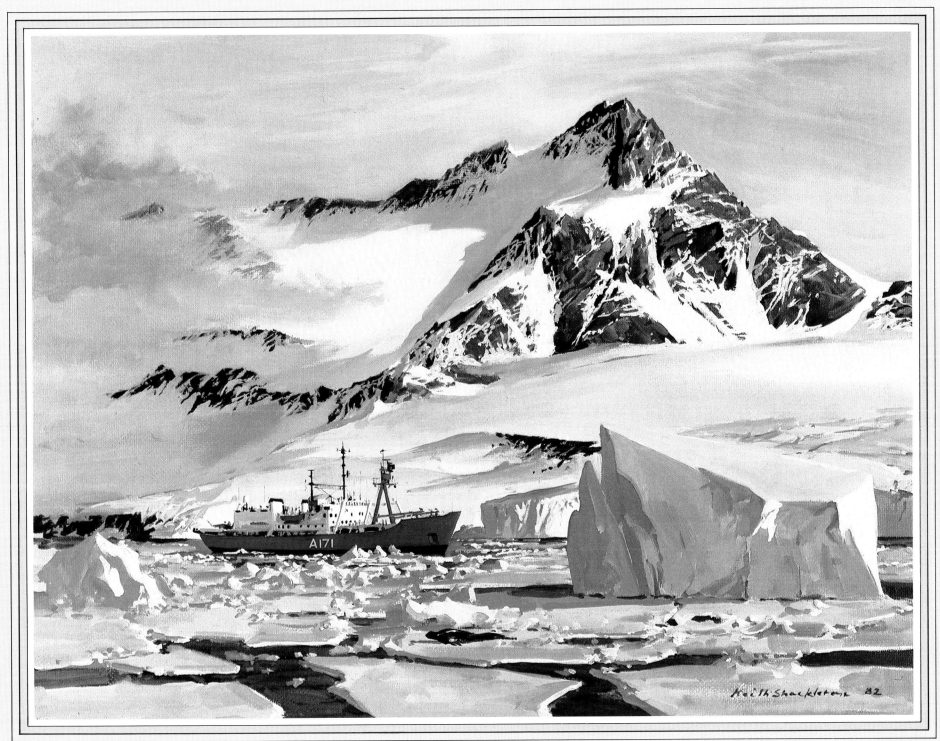

18″ × 24″

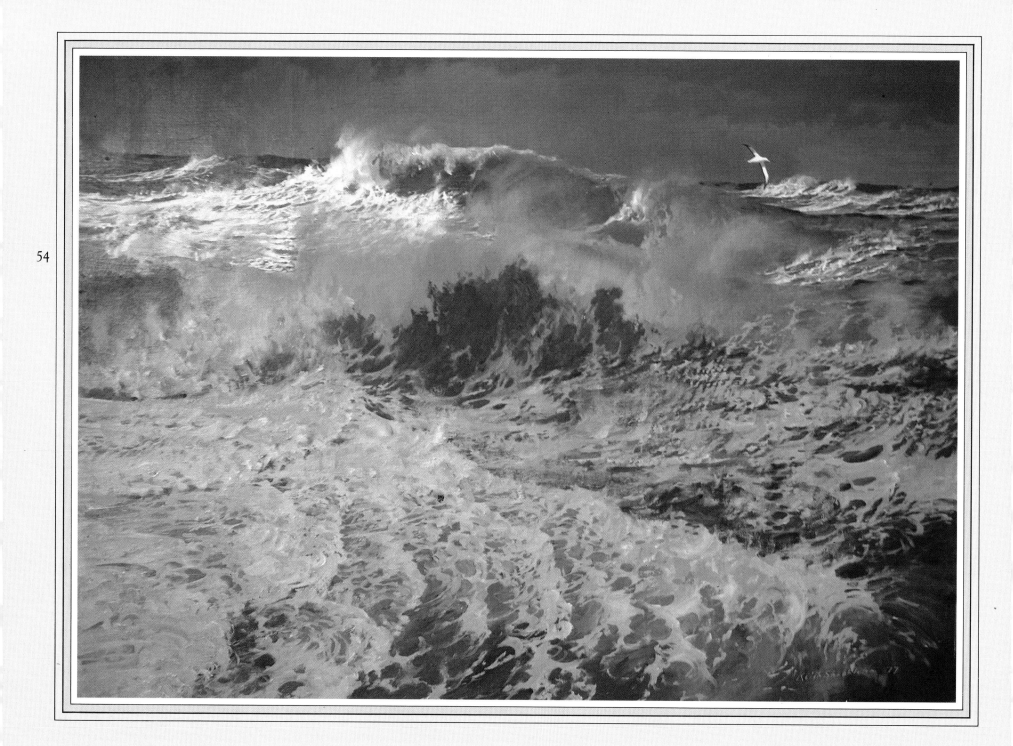

54

24″ × 36″

EVENING: DRAKE PASSAGE

There is nothing that can hold the eye and the attention longer and more restfully than the ocean. It is not unlike gazing at a fire with free-range thoughts – assuming, that is, a fire that fuels itself and never interrupts the reverie with the need to get up and fill the log basket.

No matter what the weather, when there is time to spare I find myself leaning interminably over the rail, watching the procession of the waves and white banners, or the darting, slithering reflections in a flat calm. Mostly it is a form of near-hypnosis induced by the sea's versatile movements; but the remainder comes from a respect of "Murphy's Law" which, in the maritime context, proclaims that if you go below, a whale will spout alongside, or a giant sea-serpent loop its way through the wake.

So this explains why I paint so many pictures like this. The scene produces something akin to a conditioned reflex. An albatross will slide down the trough of a wave, vault upward into the wind and catch the last horizontal rays of a fitful, setting sun. On every occasion it is as if I were seeing it for the very first time; and the reflex is to get out the brushes and paints.

I am nothing if not an optimist. It always seems possible to get a little more out of a very favourite subject. The enticing rectangle of a clean new canvas is always saying – even if it is in a very small voice – this one could be the masterpiece . . .

AROUND THE SHAG ROCKS: LIGHT-MANTLED SOOTY ALBATROSSES

The Shag Rocks stand out of the open ocean at 53° 31′ S, 42° 02′ W – about 140 nautical miles WNW of South Georgia. They are covered with Shags as one would expect and are the sort of feature a mariner dreams about in the small hours of the morning and wakes up screaming.

They are mountain peaks – some with overhangs – that soar up from the deep with no discernible hint of a shelving sea-bed. The highest is just 230 feet, in a closely knit grouping. Two satellites stand ten miles to the southeast; revealing themselves, more often than not, by an upheaval of bursting sea subsiding just long enough to betray the profile of Black Rock itself. The inevitable question follows – just how many other spires, in other places, rise from nowhere to within a foot or two of the surface without advertising their presence . . .

But this is quiet weather. The gale has died leaving a long and very typical residual swell to sweep an astonishing height up the rocks and draw away in ribbons of run-off. Above the lick of the sea the rocks are pale from the white streaks of guano and peppered with thousands of birds enjoying the sanctuary of this forbidding point in space.

In the foreground, listlessly circling, are the Light-mantled Sooty Albatrosses. Like the rest of their kind they display a great measure of economy in their wing movements – so unlike the flailing urgency in the flight of the Shags that must have been here, squatting on the ledges when the *Aurora* first came this way in 1762 and gave the place a name.

But even by albatross standards this one is special, with the highest aspect-ratio wing of any bird.

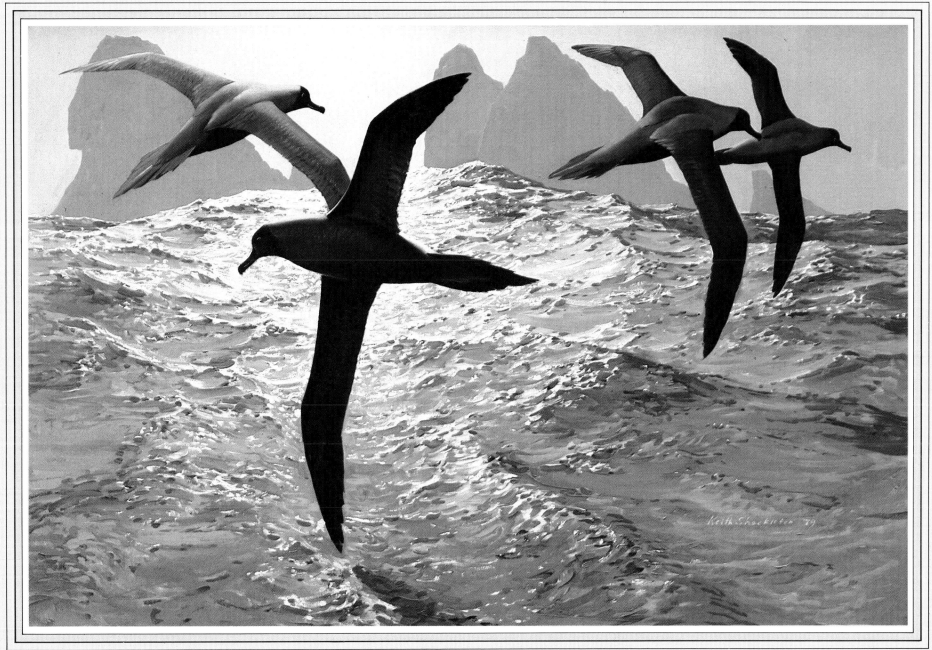

30" × 24"

Flight Instruction: Cassin's Falcons

When people are taught to fly, just as when they are taught to dive, a special element becomes inherent in the instruction. It has to do with overcoming the built-in awareness that mankind was never intended, outside his dreams, to soar in the clouds by flapping his arms, any more than he was intended to sit on a coral-head five fathoms down for 50 minutes, inhaling compressed air.

In either case any perceptive human must surely admit to a sense of unease and basic inadequacy: to a dependence on equipment rather than pure physical capability. The human mind, if worth the name, must likewise accept that this is an adventure – if no harm is intended "trespass" would be wrong. It is a moral challenge, the rewards for which are an extra, indeed two extra dimensions, to the richness of life, the experience of travelling under personal control into elements alien to the physiology of the human animal.

Then we see birds teaching their young to fly: "ab initio" was the expression used in aeronautical circles. The important thing though is that ab initio flying instruction for a bird corresponds to the mechanics of putting one foot in front of the other and walking in the terms of a human student. All young birds, when consequential feathers begin to take shape on the outer extremities of the wings, have the inherent concept of flight – they must have. They spread their still feeble pinions and feel the lift. Gravity becomes a spectre no longer but an ally, another natural force that may be harnessed at will to provide a greater turn of speed or increased flamboyance in their flight.

In my picture the two young "eyasses", top and bottom and browner in colour, have been flying for about a week. They were hatched on Carcass Island in the Falklands and, judging by the feathered remains around the eyrie, were nourished on little else but a diet of Thin-billed Prions. The grey Peregrine in the middle is the Falcon herself, and some years she raised as many as four young, with the ensuing instructive play twice as complicated and twice as spectacular.

In this "game" she is heavily stalled along the centre section, with her scapula feathers raised and aflutter with the break up of airflow. But her outer wings are in full control in response to the extended leading-edge slots, a device that had seen much service in this theatre before being "invented" by Sir Frederick Handley Page in the early 20th-century.

All the manoeuvres are directed towards the hunt. Total mastery of flight in the first weapon of the bird of prey and, after fledging is complete, the first object of parental guidance. In time the very nature of the fully-trained bird is made manifest. It is more than just its commanding silhouette in the sky: it is the predator's style of movement that goes with it, the self-assurance that borders on disdain. When training is complete, a young Falcon will fly as a Tiger walks.

ROYAL BATHING PARTY

King Penguins, of all the seventeen species, are the most elegant. Of that there is no doubt. While others may be more endearing, amusing, even friendlier natured, the King is the one with style.

On land the Kings stand tall, not far short of the Emperors, the largest of all. They would average about three feet to an Emperor's four and walk with that assured self-importance one associates with civic dignitaries and processions comprising upper echelons of the Church.

This head-in-the-air gait with back erect as a guardsman, chest and belly a swelling convex arc is fraught with hazard. On level ground there are no problems. They process down the beach in their extravagant regalia of white shirt, silver cape, saffron-yellow cravat and golden ear-muffs, long flippers modestly aswing, eyes turning from side to side in bountiful condescension. Then one will trip over a stone and fall flat on its face and only a bird of such regal composure could accept this measure of indignity without loss of face.

But they are bound for the water, and it is in the water that their whole demeanour changes.

Water can achieve this transformation in all sorts of animals from the smallest and most humble to the more dignified of our own species. It seems to have something to do with an implied licence to lower the standards of decorum and all the minor inhibitions that seek to prop it up. Water, in short, is a fun element and penguins understand this as well as any.

So the Royal Bathing Party is an orgy of athletic exhibitionism. All the repertoire of diving, porpoising, rolling and flippering movements, evolved presumably for survival fishing, are employed in the most uninhibited manner. Those of us who lay no claims to the purely scientific dread of the anthropomorphic, could be excused for believing that they are doing it as we would – for fun.

24″ × 36″

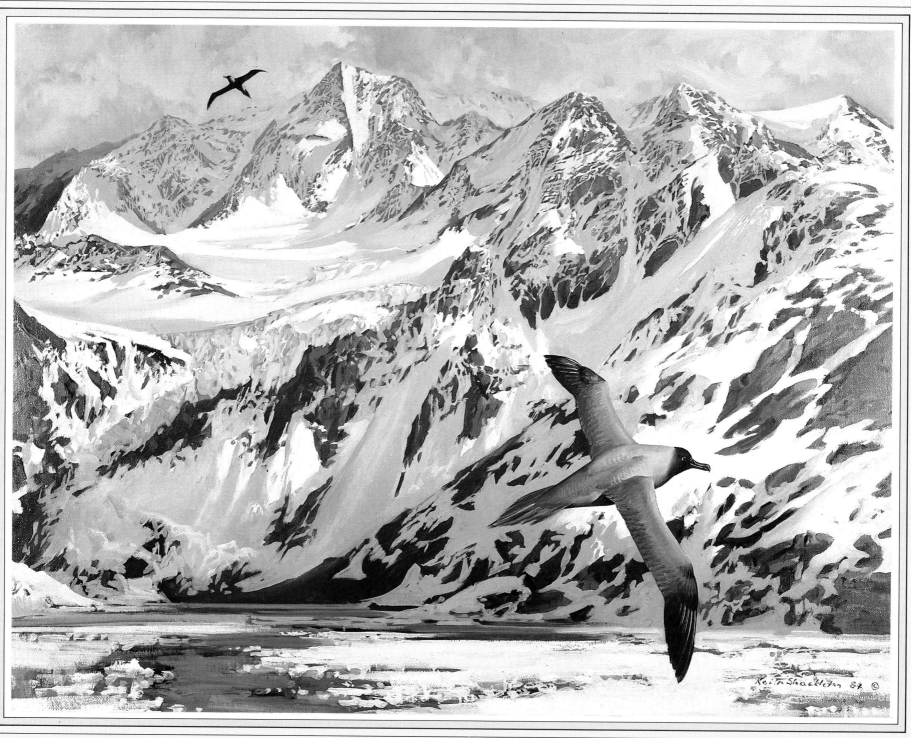

36" × 48"

THE ALARDYCE RANGE – SOUTH GEORGIA

Some landscapes emerge from a carefully planned layout, using roughs, alterations and general dummy-runs, intending – often with more hope than expectation – to launch a "great work".

Often I find myself painting this sort of picture grotesquely large, as if dimensions for their own sake would add an element of artistic import. Alas this is not the way it works, rather the reverse. If a picture is destined to be really bad, the smaller it is, the better for all concerned.

I have been telling myself for years that I must learn to paint little pictures, that there is no intrinsic merit in size. But painting big pictures is like alcoholism – the habit is hard to break. Moreover it is commercial folly, they call for wall space that is in ever shortening supply – and probably accounts for my owning the largest collection of original Keith Shackletons in Europe.

Having said that, I must explain that there are scenes of such pole-axeing wonderment and splendour, that I can not make myself think of them in formats of less than three feet by four and feel the urge, even the necessity, to assault the challenge with the sort of brushes more reasonably employed for creosoting hen coops.

"Weight as such" said the great yacht designer, Uffa Fox, "is useful only to the designer of steam-rollers." And much the same philosophy applies to size.

But the Alardyce Range was certainly a maximum acreage subject and there was yet another, purely sentimental reason calling for a big picture. The occasion of it was one of deep content.

There is always the odd day when two or three of the ship's staff can take a boat and under the praiseworthy mantle of "research and reconnaissance", go off on a little expedition of their own. It reminds me of escaping from school to watch badgers, and this picture was the result of one such opportunity.

South Georgia, however much one may love it, is hostile and built on end. No better comment can be conjured up than the words of an Essex oysterman who found himself caught up there in the whaling industry in the twenties – "If this place were t'be flattened out – she'd be *huge!*" But it was not just the mountains, the weather really sealed the success of the day.

On very rare occasions the sky can be cloudless, visibility seems infinite and the peaks stand there like crystals. This day was not quite that but nearly there. Cloud lay on the high tops but the sun shone down. There had been a new fall of snow but the tussocks were warm, you could walk and climb in shirtsleeves and it was good to be alive. I sat on a little cliff-top and drew the ice fields and the lower levels of the rock – while my shipmates took photographs.

Half way down the cliff a pair of Light-mantled Sooty Albatrosses had their nest. From time to time they would take wing and fly their circling courtship display against the backcloth of the mountains and the deep cobalt blue of the meltwater lakes.

It was simply a picture that had to be painted and the bigger the better – if only as a gesture of gratitude for the company, the opportunity – and the subject.

South Georgia

A gale of wind is as much a part of this lovely island as the Wandering Albatross that rides it. On this occasion the gale was not particularly significant. What had struck me most was the elemental layer-cake that the subject presented.

In more or less equal parts were sky, a scramble of ice, snow and rock across the middle and a base layer of rolling ocean. I had no feelings that either one was more important than the others and settled for bands of roughly equal depth and from the standpoint of the composition, equal in strength.

For all that, the three elements are strikingly different. I tried hard to convey the feeling that the top and bottom layers were volatile, ever-changing and capricious factors while the middle was fixed, resolute and forbidding – wonderfully inhospitable at *all* times.

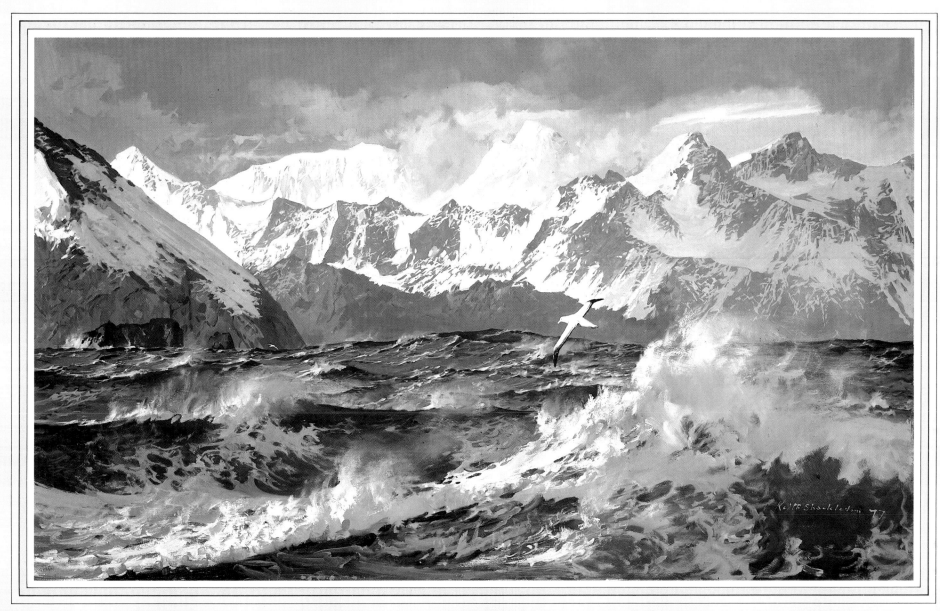

65

24″ × 40″

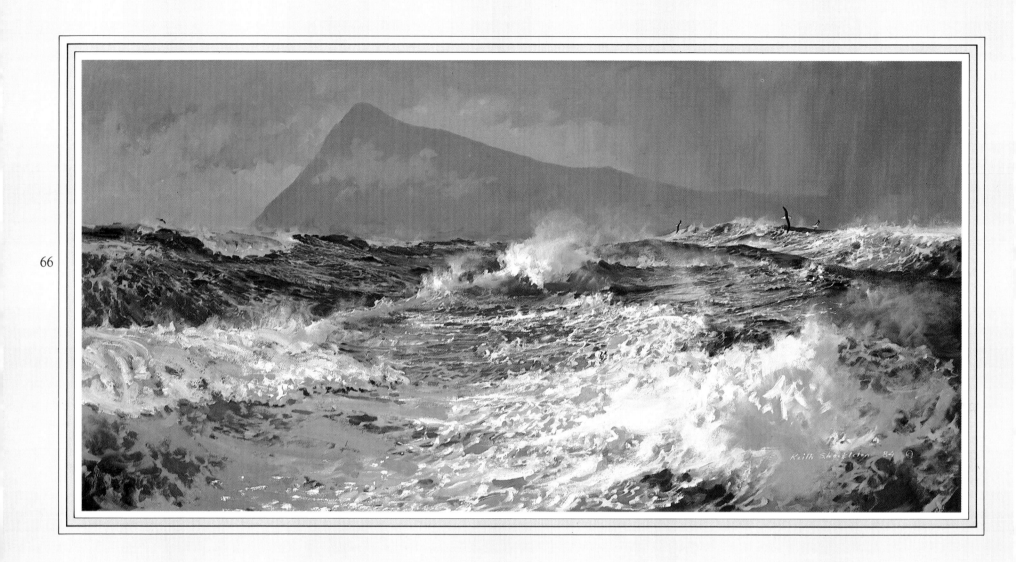

66

24" × 48"

CAPE HORN

The outline of the Cape makes the simplest of drawings, and the outline is all that is needed. The land mass itself under such weather conditions as these is flat like a cut-out, monotone and monochrome, and the rest of the picture can be carried in the mind . . .

Capes, "the furthest limit of the land" as Herman Melville described them, have a special fascination for mariners, based on a consciousness of the great continental interior that lies inshore. Finisterre, Hatteras, North Cape, Good Hope, are ocean bywords, but even though it is not a cape at all, the Horn is the one that says most.

This rugged island, so interwoven with thoughts of windy weather, horrendous seas and the Lutine Bell, brings out the romantic in all of us. It is impossible when ashore there, not to fill the pockets with grey granite pebbles, elliptical or round as little Dutch cheeses, that have tossed and slithered on the beaches for millennia before human history touched the Cape. Erosion and tumbling has perfected their shapes, making them as pleasing to look at as to hold in the hand.

Extending from the most southerly tip of the Cape is the hypothetical meridian that separates the Atlantic from the Pacific Ocean. To the north is the entire New World. They are all considerations to conjure with, and they tend to make a nonsense out of me as someone perhaps over-susceptible to their impact.

I fear this calls to mind another of my more unusual friends who saw each day as filled with new experience, and himself as a setter-up and breaker of world's records far beyond any esoteric boundaries acceptable to Guinness.

"Do you know," he once said, looking up from a frying pan sizzling over a driftwood fire at a place called Ballinaboy in western Ireland, "I am probably the only left-handed veterinary surgeon to be currently making corned beef fritters in the whole of Connemara."

Now this is not the *non sequitur* it may seem. The occasion came back to me in sudden and sharp detail at Cape Horn. I was watching a pair of Andean Condors in leisurely spiral over the southernmost tip where Drake had sat – the highest point in my picture. It was a much more inviting day than this one in the picture, with sunshine and a gentle breeze from the north. The birds were gaining height without effort in a healthy thermal from the warming slopes below, and the thought that brought my friend and his fritters to mind was that as they described their leisurely interwoven circles in the sky, I was suddenly conscious of looking at, in turn and turn about, the most southerly Condor in all the world . . .

FORCE NINE IN THE SOUTHERN OCEAN

Nine on the Beaufort Scale denotes, officially, a "strong gale" – 44 knots and over. Force Nine, gusting Ten would be perhaps more accurate for the amount of white water in this picture. Force Ten is a "storm", beginning with wind speeds of 54 knots. But it is all getting a bit academic here. A wise man would be somewhere else.

Knobbly weather can happen in many other places, generally does, and the waves all look much the same. But here we have an albatross – and the Southern Ocean is positively identified.

The bird's presence however, does more than just fix the location. Although tiny, it has an importance in the picture out of all proportion to its size. The subject content is simple – a tumultuous mass of water and one very small bird. This implies that the sea has to be the dominant part of the planning. The shapes had all been worked out, organized and put together with no more than the idea in the back of my mind, that this single bird would be in there ultimately – somewhere.

I needed a wild ocean to convey the enviable composure of these pelagic birds. Close up, they give not the slightest hint of concern. Their aerodynamic trim adjustments are as quick and instinctive as their sense of whereabouts. They are actually enjoying it. The only concession they make to this meteorological mayhem as the wind pipes up to 60 knots is to crank their wings a little, reducing the area, just as we might, under circumstances more in tune with our capabilities, roll up our sleeves.

Now I come to an admission. With this picture and with others in similar vein I resorted to guile, which a painter who could properly visualize would never need to do.

I knew the size the albatross must be for the impact I sought. I knew the attitude I wanted to keep him in tune with the elements, and I knew the scale of a bird which in reality is over eleven feet across the wings but still looks dwarfed by mountainous seas.

What I did *not* know, was exactly where to put him in what was now a nearly finished picture. The only answer was to draw and cut out a little cardboard albatross the size I wanted, and then . . .

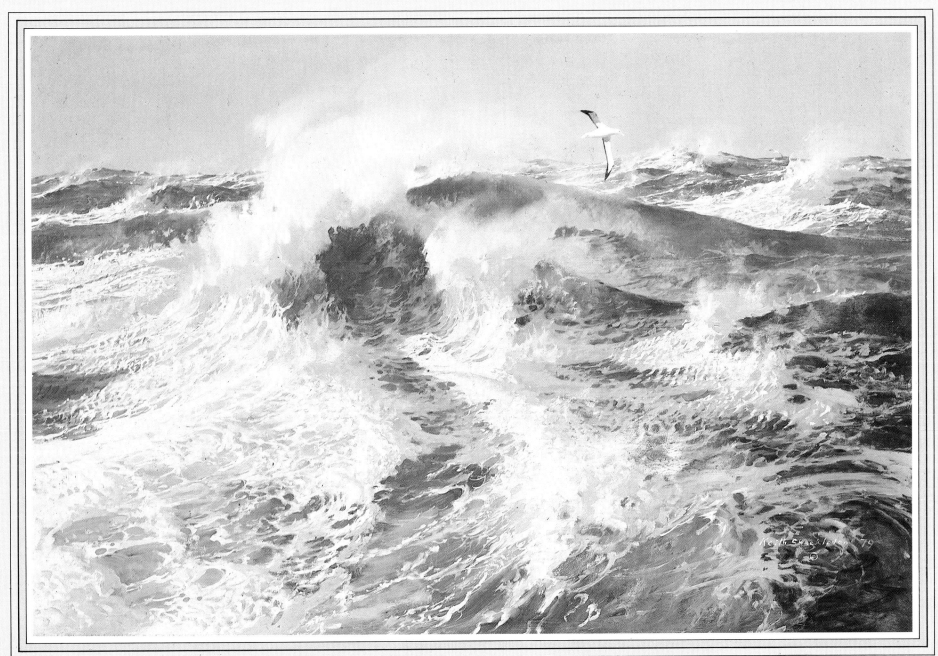

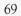

24" × 36"

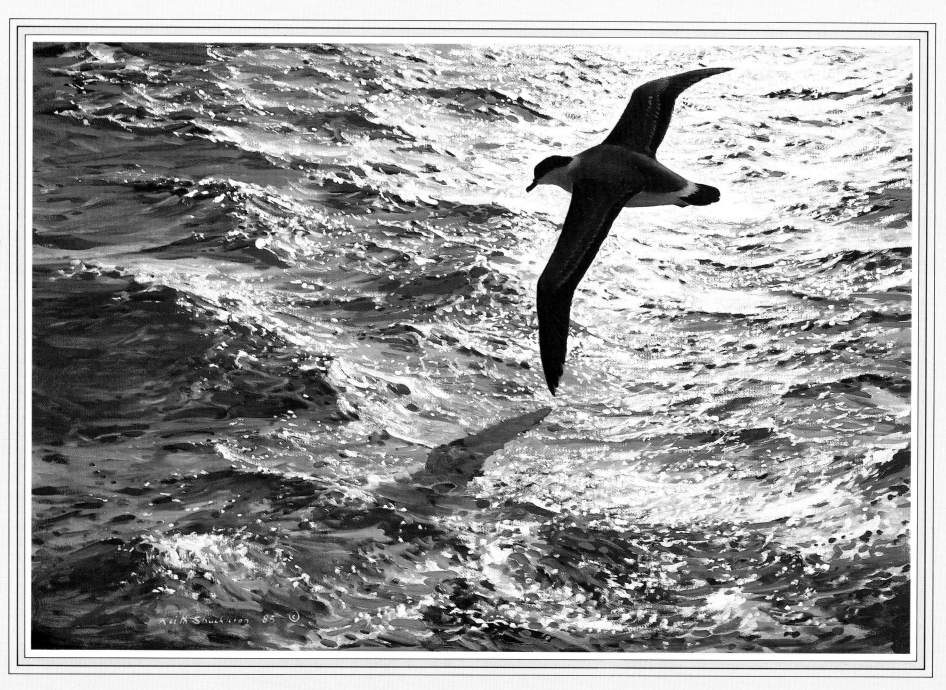

24" × 36"

ALONE – GREAT SHEARWATER

The birds of the ocean are characterized more by patterns than colours. After the kaleidoscopic extravagance of some of the land birds, especially in the tropics, seafaring species are almost in monochrome – white, black with brown or grey or blue-grey, barred and spotted sometimes, and only occasionally treated to some bright accent on the bill, the throat, the eye or the legs, like a discreetly dressed diplomat with a carnation in the buttonhole.

The Great Shearwater has no such carnation. Its markings are clean cut and distinctive, but sober. One of the few of a big genus that is instantly recognizable at a distance and with the naked eye, but what it lacks in adornment, it makes up for in mystery. Once in a while a Great Shearwater has come aboard in the night, shaken but unharmed, and can be released the following morning. It is a big strong bird to hold in the hand, but ridiculously small in terms of its environment.

They breed, all of them, in the Tristan da Cunha group, Nightingale and Inaccessible Island of the South Atlantic with a very small satellite population across in the Falklands; yet they use this entire ocean as a playground from the high 50s south of Cape Horn to Good Hope, up to the fjords of Norway, to Iceland, and into Baffin Bay north of the Arctic circle.

In a way it is even more intriguing, this circular sort of movement, than the generally north to south trend of so many migrants, probably because we would find it more difficult to plot ourselves. I am forever trying to figure out what goes on in the mind of a sea-going bird like this, whether or not it carries a picture of its home burrow on Nightingale as it sweeps back and forth between scattered ice off Greenland seven thousand miles away. When it is passing off Cape Finisterre in our northern autumn, does it instantly know the course to set for home – those tiny islands plumb in the middle of the South Atlantic where a pressing engagement awaits at the end of the austral spring?

The required data to answer all these questions must be ticking over inside the little dark-capped head with the black boot-button eyes as it pecks away at a well-meaning finger, struggles and flaps in readiness for release.

Once over the side it is away again, alone, beautifully composed, shearing the water in the manner born, and possessed of an uncanny and most enviable sense of where it is and where headed in the wilderness of the ocean.

SOUTH FROM NEW ZEALAND – BULLER'S ALBATROSS

There is one feature about albatrosses, even the smaller "mollymawks" of which Buller's is one, that sets them apart from the general ruck of birds. It is aerodynamics.

Theirs is a wing shape that has inspired so many designers from the very beginning. It is the long and narrow wing that bestows the shallowest angles of glide; that in still air could offer something like 30 feet forward for one foot of vertical descent. Still air is anathema to an albatross. They are creatures essentially of the wind, their flight style demands it both for its own sake and for the waves the wind provides over the ocean. Once waves are established, a contented period of slope soaring can begin. Varying degrees of wind and waves are a virtual constant in albatross latitudes, and the birds will respond to this condition with an air of detachment, an automatic and instinctive pattern of flight designed to harmonize with the rolling contours of the sea.

And they never, if they can possibly help it, flap. The result is a stiff set to the wings, slightly downpointed, at times almost rigid. Though the banking and upward vaulting is often extravagant in the extreme, the changes in the wing attitude are minimal, and this makes them lovely to draw. They can be drawn like aeroplanes, the actual perspective of the wing accurately worked out at leisure without having to rely on a quick eye and a retentive memory.

Anatomically I think the feature that makes the albatross wing shape so immensely pleasing is the even way it is divided into three: the inboard section corresponding to our upper arm is very long, so that like us, the length from shoulder to elbow is about equal to the distance from elbow to wrist. The albatross flight feathers from "wrist" to wingtips are equal again. It makes not only for a profile of aerodynamic perfection and great beauty, but a wing that may be stowed with ease into a very economical space.

And this is how they sit on their nests on the cliffs of Snares Island and Solander, their shapely wings neatly stowed with tips crossed above the tail, waiting for their single egg to hatch with the same look of serene timelessness they carry in flight. The Buller's mollymawk is distinctly marked and easy to tell, with the under-eye shading and the striking white brow. Its elegant presence, day after day, is a special bonus on any voyage south from New Zealand.

24″ × 36″

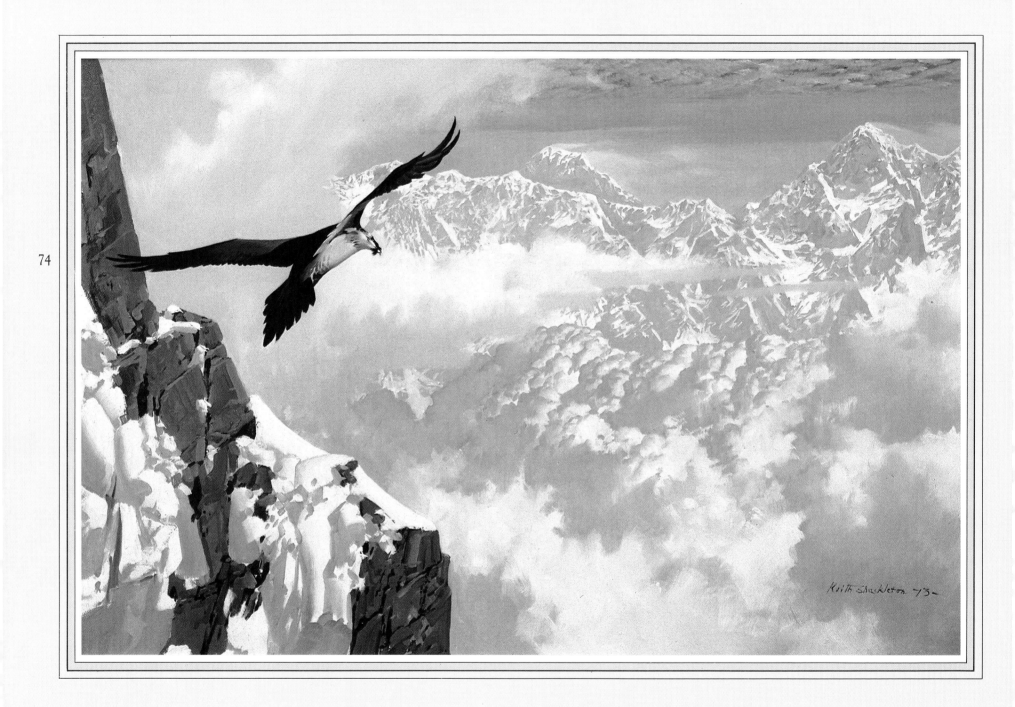

30″ × 48″

LAMMERGEYER AND THE GREAT PEAKS

There are certain animals that seem doomed to a bad press. For serpents it began in the book of Genesis, Chapter III and never let up. Sharks have fared badly, their undeniable beauty never quite managing to supplant their sinister legend. Spiders, to most, are a walking shudder. It is never easy from the standpoint of conservation to stir the human heartstrings over the fate of crocodiles; and ever since Count Dracula, the dice have been loaded against bats in the popularity polls.

There is perpetual conflict afoot between looks and connotations, and in common with all issues based on personal preference, with a measure of atavism, folklore and superstition thrown in, the most obvious missing constituent is logic.

Vultures are a prime example. They represent the opportunism of death. They are, by conventional standards, unlovely to look at because they tend to have no feathers on their heads. That one is the functional outcome of the other and that the job they do is both vital and well done, is again insufficient to raise their threshold of popular appeal. Their habits and their appearance have condemned them to be the unchallenged symbol of avian nastiness.

Then comes the Lammergeyer, a vulture if ever there was one, but possessed of a romantic sounding name and a feathered face. In addition it has the trim lines that could just pass it off for an eagle. It breaks through the barriers of prejudice and is looked upon as a proper bird of prey; an image further enhanced by living (among other places) along the foothills of the highest mountains on earth.

Lammergeyers do for vultures what Blue Tits and Robins do for garden birds. They put over a public relations message that benefits all, and spreads around a little affection and respect that might not otherwise have come their way.

These were the kind of thoughts that ran through my head as this particular Lammergeyer, oblivious to the aberrations of the human mind concerning birds in general and vultures in particular, passed and re-passed along the ridge. Sometimes it would look straight into my eye as if willing me to get the most of this opportunity for study and admiration, then go home and paint a picture . . .

It soared over the emotive rock inscriptions of the Upper Khumbu Valley, and the little monastery of Thyangboche, in the dry, thin air as the monk struck the bell.

It was a scene hard to leave even after the bird had gone. The clouds gently dissolved into haze, the skyline profile of the Himal sharpened its edge. These are the greatest of all mountains, Nhuptse, Lhotse and Everest. Ama Dablam, 22,500 feet, is closer than the others and looks by far the highest through a trick of perspective. As the sun goes down, one by one the great distant peaks lose their colour and drift into violet shadows only fractionally darker than the sky beyond. Finally there is one magic moment when the last of the sun's rays confirm, by their fleeting touch, the one that is highest of all: the last glow lingers on the summit of the ultimate mountain. This is Everest's moment and hers alone. It is like a coronation and brief though it may be, it is forever printed on the mind.

THE NORTH FACE OF EVEREST

This painting was based entirely on photographs and there was something special about them. The circumstances of the commission and my own acceptance of it were interesting too, and so in the end was the fate of the picture itself, after the work was done.

In the Introduction, I mentioned my feelings about photographic reference because it is a question so often asked. This was, I felt, a good example of justified use to the degree of the unavoidable, because this is a view I have never seen.

Captain John Noel was official photographer attached to the Everest expedition of 1924. He took beautiful pictures and the prints he gave me were from plates very clear and sharp and of a monochrome that was not quite black and white and not quite sepia. The camera itself must have been both big and heavy.

In those days all the attempts on Everest started on the Tibet side and this was no exception. Access to the mountain through what was then forbidden territory was achieved by the good diplomatic relations established by Sir Francis Younghusband, then President of the Royal Geographical Society, and Everest attempts through Tibet filled those early years.

Over half a century later Captain Noel, one of the last surviving members of those expeditions, went through his old pictures and decided that they must form the basis of a painting to honour the early pioneers on the world's highest mountain, and the man who had made it possible for them. His plan was that the commissioned painting should be reproduced as a limited edition print under the sponsorship of the Royal Geographical Society, with the proceeds going to the Everest Foundation and Sir Edmund Hillary's Sherpa Hospital.

To me it was an exciting task which might have been a lot harder to accept had I not a year or two before painted the mountain from the Nepal side. Having seen it, experienced the strange thin air and the whole magic aura of the place, I felt able to interpret John Noel's photographs with a degree of honesty in colour as well as atmosphere.

This reconstructive, once-removed sort of picture is something that comes seldom my way, and when it does is always accompanied by a measure of trepidation. During that time though I had much helpful advice, to say nothing of unfailing support and encouragement from General Jim Gavin and Eric Shipton, to whom Everest and her fickle moods was something they had lived with for months on end over many years and remembered in detail throughout their lives.

So with their help and John Noel's the work proceeded, the picture was finished and publicly unveiled. The print edition, the most faithful of reproductions, was prepared by Royle's. Immediately after, almost as if reproduction had fulfilled the whole purpose of the work, the original painting was caught up in a still unexplained fire at the Mall Galleries in London and was totally destroyed.

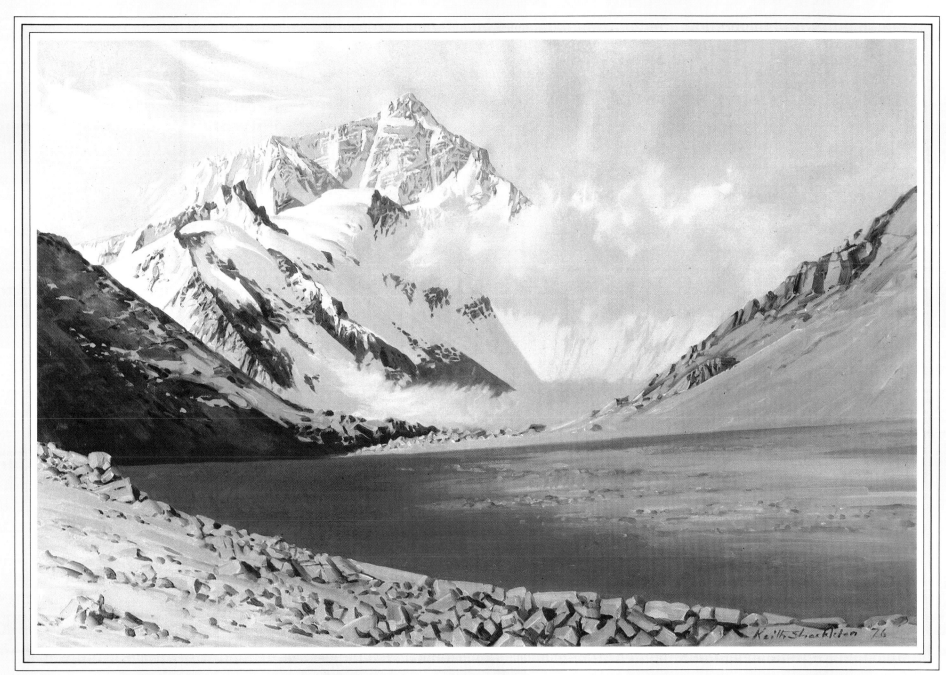

24″ × 36″

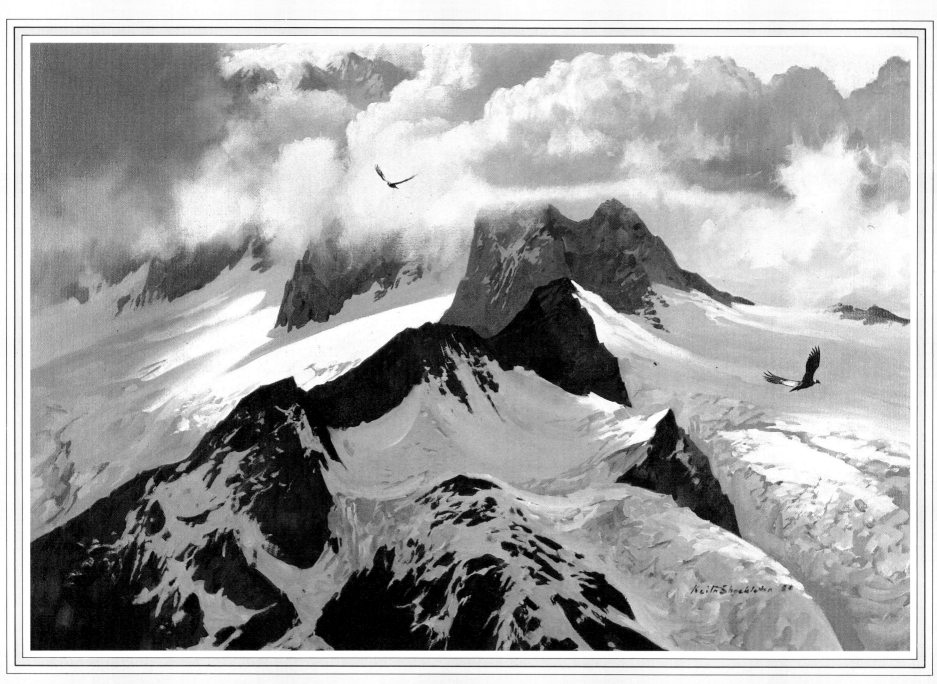

24″ × 36″

CONDORS OVER THE DARWIN RANGE

There were just two of them, soaring on the same curve, the same wing down, tracing their separate circles. Sometimes the circles would overlap as one, the birds at opposite sides and therefore in opposing directions, their self-imposed diameter apart. They maintained perfect station, neither gaining nor losing on one another for minutes on end.

Their mean height was slightly different, affording three dimensional separation, but complicated by the chosen circuit enjoying differing degrees of lift on different sectors. At one point the lower bird would be swept upward by a gratuitous heave of rising air until it could look down momentarily on its mate, only to lose it all further round the circuit and find itself once more, below.

As the circles drifted apart and moved tangential to one another, the birds would suddenly be passing at the component of twice their individual speed, separated from a collision course by little more than a foot or two of height. Then there would be a fleeting but discernible interchange, each acknowledging the presence of the other as they sped past. There was no time for chat, just an appropriate equivalent of "*Buenos dias*" – for they were Andean Condors.

This bird seems to carry with it, on those wings of exaggerated dihedral, a sort of distillation of the Andes.

There is no mountain range, or cordillera perhaps, that is longer and less peopled. The Himalayas win on height, but three Himalayas would fit into the Andes' length.

In the far south latitudes of Chile, where the range meets the Straits of Magellan and strolls on in stepping-stone islands towards Cape Horn, the Darwin Mountains are its last continental massif. Fjords and glaciers from them give on to the Strait and the dense forests of *Nothofagus* which leave a scent, in the air and on clothing, that will survive weeks in a duffel bag.

This is where the Condors begin. The first I ever saw were a group of five feasting on the carcass of a Commerson's Dolphin washed up on the shore of the Beagle Channel. That was an awful lot of Condors for a first look, and the sort of undignified *mêlée* that devalues the currency of this legendary, high-altitude, rarified-atmosphere bird, supposedly for ever on the wing. That they should be caught at vulgar carrion-eating games, and at sea level too, is a bad blow to the Condor image. But my next sight of one was in the accepted place, among clouds and mountain peaks, and all was forgiven.

Since watching those five, I have seen them at many different points of the Andes and the striking thing about them is that in almost every case they were the only animals of any kind to be seen. Sometimes it would be a pair, sometimes a single, the silhouette of the only life in the sky. All the way from the Darwin range to the Altoplano of Bolivia and Peru – the birthplace of the Amazon where clouds seem to be sweeping the roof of the world – there would be a Condor. You might have to look hard for it as a speck in a very wide sky. But it would be there, tracing its own circle with a radius of total freedom.

In the Islands – Bald Eagle

Finding this particular eagle and its mate marked the end of a quest.

I had been working in Alaska with the general brief in the back of the mind to paint a Bald Eagle. They are splendid birds, the emblem of the United States of America, and therefore much painted, which put me subconsciously on the lookout for an eagle either doing something out of the ordinary, or in a setting less than commonplace.

Alaska is a rewarding place for eagles because there are so many of them. It is not unusual to see "flocks" around the gravelly deltas and sand bars when salmon are running. They vie with gulls for prizes when bears have flicked out a good fish and discarded it half-eaten on the shingle. But the classic pose of the eagle, and there is one demonstrating it at almost every turn of the fjords, is sat on top of a dishevelled and lichen-draped spruce with rain dripping off the end of its beak.

The year this picture was painted, we had begun in the southern panhandle in true eagle country of spruce and hemlock, creeping mist and silvery rain, but we had been heading north towards the islands of the northern gulf. The weather brightened, the trees were gone and the eagles were fewer and further between. They were now sweeping over wider landscapes with much more sky.

Then one day I found this pair nesting on a sea cliff, riding the updraught as they circled before returning to their eyrie wedged into a crag below. It was a north facing cliff with the crag in shadow until late in the afternoon, so that as they rose, each bird would soar in the shade, climbing steadily upwards until suddenly it cleared the rim of the cliff and was flooded with sunlight whilst still against the shaded sea below. Somehow at this precise moment, they each in turn looked very much like what I had been seeking, and I went home happily determined to do my best with what they had offered.

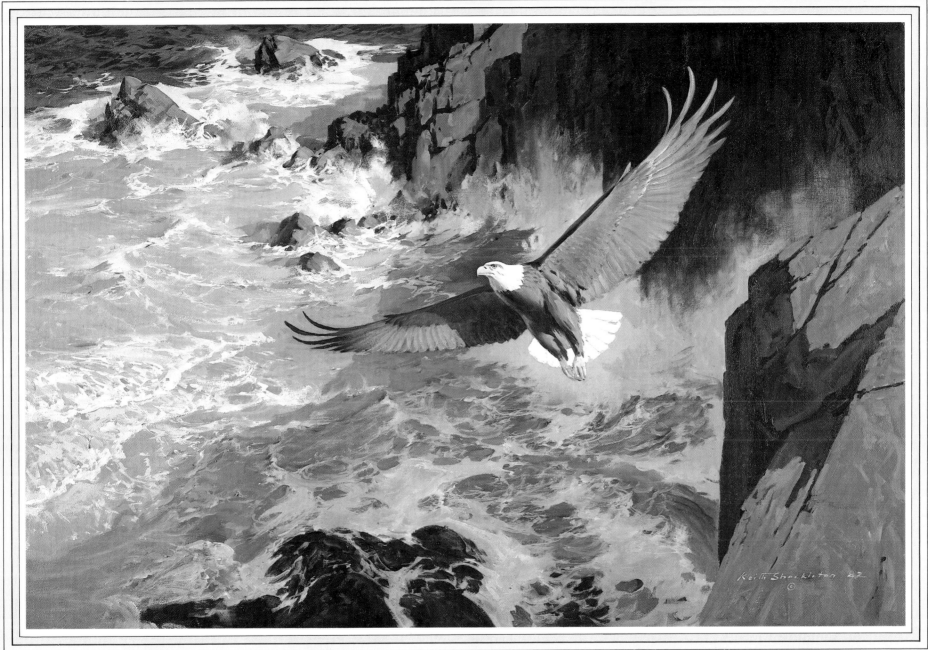

24″ × 36″

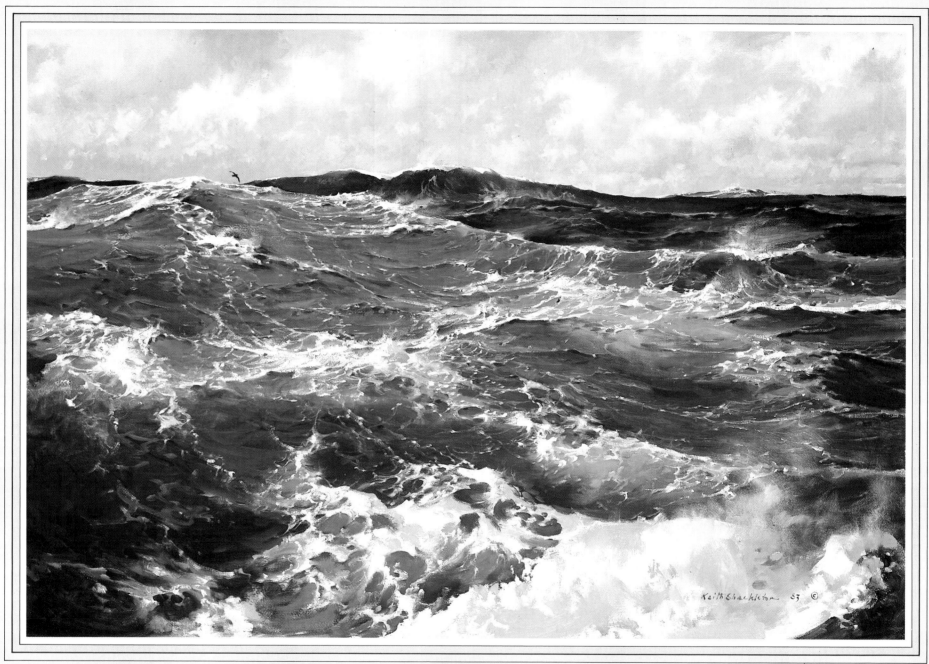

82

24" × 36"

OFF SOUNDINGS

In painting terms, seascape is many things to many people. To those who enjoy pictures but never paint, it is quite a popular subject. Even to self-confessed landlubbers the sea brings a message of escape. But it has also acquired the reputation of a subject so difficult to portray that a lot of painters will go into a state of moral collapse at the mere thought of it.

For me to suggest that the reputation is ill-deserved would imply that I not only find the subject easy but what is worse, that I am satisfied with my own efforts, and that really would be nonsense.

What must be said is that seascape is in fact no more difficult than any other subject. It calls for the same careful observation and demands the same attentive analysis of what goes on. Just as the painting of a nude in a life class is hopeless without some understanding of underlying bone structure and muscle groups, the painting of moving water calls for some awareness of the forces that set it in motion. Seas do things because they respond. If nothing happens for long enough, they become mirrors of the sky above or whatever else is there to demand its reflection.

The most modest of breezes begets catspaws and ripples to darken the surface. Currents in the water body itself, flowing over an irregular sea-bed, will leave a surface expression. The two forces vie with one another as the breeze becomes wind and the wind becomes gale, between them manipulating the shape, the period and the whole character of resulting waves. If the water is deep and the fetch is great, they could form an ordered procession. In shallow waters, or with a weather-going tide, it could be turmoil.

Once there are waves, there are discernible, three-dimensional contours, positive as sand hills in the Sahara, and the painter has something to work on.

Next comes the influence of light. Each wave will be lit on the favoured surface and shaded on the opposing side. In trying to paint it, tones are beginning to give a feeling of mass to the simple, delineated profiles of the first drawing.

All that remains now is superficial detail, and this means no more than treating it to the same observation that any subject demands, and this can be a most enjoyable part. Subsidiary wind ripples chase each other over the principal heaving mass of every swell. Lacy patterns of foam overlay areas of opalescent cloudiness where air has been ground deep under water by the weight of a breaking sea.

As the wind blows stronger the nature of the pattern changes; parallel ribbons of spindrift lay stripes on the sea. Crests will be whipped off in flyaway banners that in sunshine form a momentary rainbow – and many people will be very grateful to the inventors of Dramamine.

But this seascape is no wild one. It is an "off-soundings" scene, far from any influence of land or shoal. Blowing over it is what one would term a "nice sailing breeze". All in all it is a sea condition with no great drama for a painter; just the sort of sea that is always lurking in the mind when thinking of this particular avenue of escape – a sea with plenty of interest but no vice.

BLUE WHALES

I have never seen a blue whale under the water and not very many on top, so a little fantasizing has gone into this picture. Twin calves, too, are believed to be rare but not unknown, and had wishful thinking been allowed full rein I would undoubtedly have opted for triplets at the very least. The largest animal that ever inhabited the earth faces extinction at the hands of the most lethal. The largest animal likewise has the largest brain, but the most lethal, with a fair conceit, calls himself "*sapiens*".

It all began long ago when some unlovely hominid picked up a stone and slung it. His hands from then on were his passport to success as an animal and to a richer life – or would have been had not these new-found capabilities fast outstripped the cerebral balance needed for prudent direction of such magnificently clever handiwork. *Sapiens* was simply not quite *sapiens* enough. Individuals who could make a Venus de Milo or discover a cure for cancer have always been thin on the ground, while the big, braying, insensitive mass of the species understood only how to dominate and destroy. I love my friends too dearly to be a fully paid-up misanthropist, but I must admit to something less than admiration for the human race in its wider, faceless sense.

Whales have no hands, yet they have a brain which gives every indication of being as nimble and sophisticated as ours. They present a situation that is overwhelming in its scope for conjecture. They know pain and bereavement; they cannot write their thoughts but they can think them. They can build nothing but their lives and inter-whale associations, cruise the seas, feed and raise their young. But anyone who has had the privilege of being close to them, of touching them, of swimming underwater with them, will confirm a human-style rapport.

They seem to be trying to make contact, and seem to know with unerring instinct which individuals among us are trying to do the same. Their gentleness and "human" consideration – enhanced by their gigantic size – are unbelievable and in view of what we have done to them in the past, they display a level of forgiveness that, in our terms, would be more easily attributed to God.

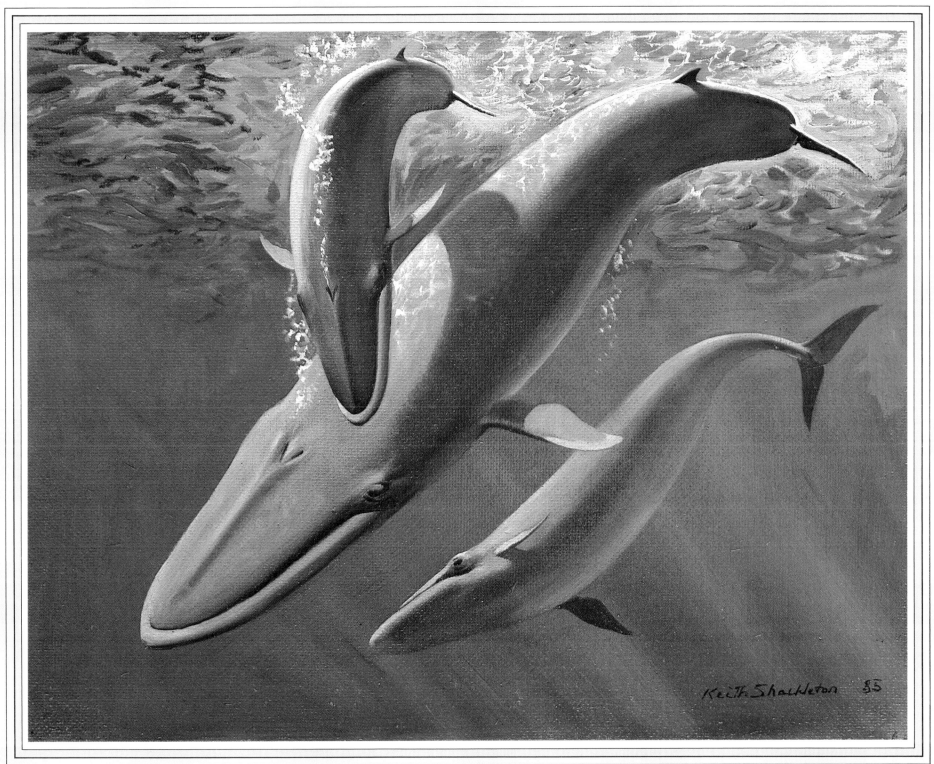

18″ × 24″

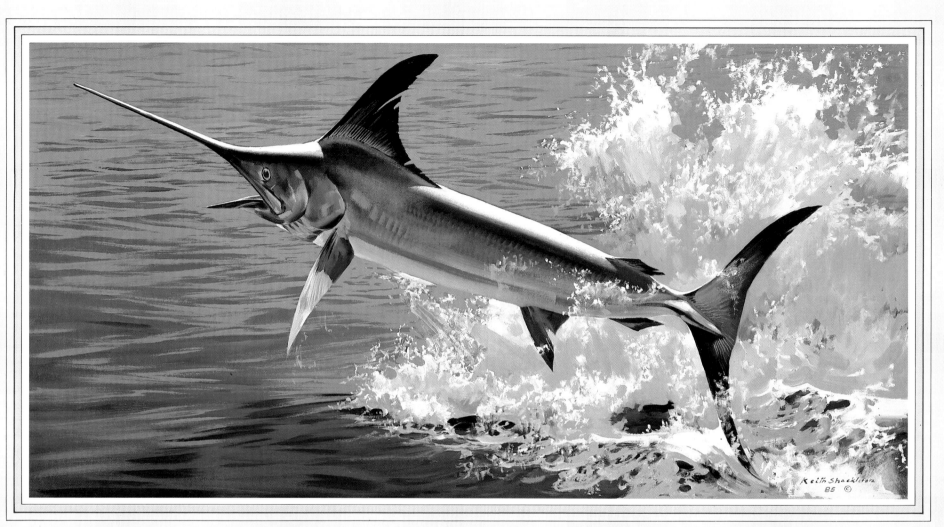

24″ × 48″

EXUBERANCE IN THE BANDA SEA – BROAD-BILL SWORDFISH

The only connection this picture has with polar regions is that it all happened roughly equidistant between the two. I include it without apology because for one thing it illustrates a particular type of picture and for another, to go from high latitudes north to high latitudes south and vice versa, one has no option but to pass through the tropics.

Swordfish do this and do it often when they are hooked. This one was not. Its motive, shared by several others that day, could have been the itch of dermal parasites, it could have had some special hunting value, or it could, as it certainly looked, have stemmed from sheer exuberance. In the right places and on those flat, hot days it is not a rare sight, and characteristic behaviour for many of the different bill-fish species.

The oily calm explodes into a welter of spray, the great bright body walks wildly along on its tail, spear pointing to the sky, then crashes back flatlong to raise the biggest splash and maximum noise as if this alone was the object of the exercise, like an exhibitionist human youth in a swimming pool.

Anyone who paints wild animals will know this category of subject: it is immediate, short-lived and of lasting memory. It is also inordinately spectacular. It might only have lasted a full second, but in that time it has managed to imprint an imperative subject on the mind that will keep on presenting itself in a demand to be painted.

Fish, by the very nature of the medium in which they move, have to be fascinating shapes. When their lives are conducted in the seclusion of caves and coral, where survival consists of backing gingerly into crevices too small for others in pursuit, turning in their own length, moving up and down like a yo-yo, or lying flat on the bottom looking like something else, shape and colour alike run to the widest set of rules. It is when they operate in mid-ocean, in the deep blue water, that the lines of the thoroughbred develop. These are fish so perfected in streamlining that even the pectoral fins are countersunk into their bodies to reduce even further what must be the most minimal drag. Their skin is smooth as polished marble. Their disposition of colour and tone is so subtle as to render them all but invisible in a world with no hiding place. Their speed and power are phenomenal.

Of all these gorgeous pelagic fish, it is the swordfish group, together with the sailfish and marlins of various kinds, that I find most exciting. When it comes to a final choice from so elite a circle as this, I think it would have to be the one in the picture – *Xiphias gladius*. The Broad-bill Swordfish, with its bill flattened and longer in proportion than any of the others, gets my vote for shape. It can be found in all the world's tropical and temperate oceans, and though size and beauty have few points of contact, it is also the biggest.

DOLPHIN ESCORT

They would be there every morning, sometimes two or three, sometimes twenty or more, keeping perfect station just under the flare of the fo'c'sle.

They were Common Dolphins – *Delphinus delphis* – and like so many other animals with the depreciating prefix "common" are in fact among the most beautifully marked of their kind. Their appearance became a ritual which lasted five or six days, for the full length of the Sea of Cortez. They must have been different dolphins, but their response was the same. Sometimes they came at night, marking their tracks with fiery trails of phosphorescence in the sea. More often they would make their rendez-vous soon after dawn in what seemed to be a constant weather pattern of breathless, anticyclonic calm.

A heavy mist lay over the sea upon which the ochre desert of Mexico, cactus-strewn and rocky, seemed to float, and the ship herself was saturated with dew until a climbing sun burned it off.

I used to make a cup of tea and take it up forward to the stem-head to watch the dolphins go through their routine, matching the exact speed of the ship, changing formation among themselves so that each in turn would come across for a friendly rub against the steel plates of the hull before shearing off, crossing the tracks of the rest and resuming the parallel escort.

The most fascinating thing of all was the colour.

While under clear water they were sharply visible, overlaid by the marbled mesh patterns of light from the surface, but their colours were cold. They were laced with blues and greens and a strange eau-de-nil from the pale markings of the undersides when they swung away.

But each time they surfaced there was a sudden resolution of the true warm colours of a Common Dolphin – gold and deep sienna brown, black and white, which lasted as long as the leap; shooting ahead of the white water that bursts under the powerful drive of the flukes.

Sometimes only a dorsal fin would scythe through the surface, preceded by a quick exhalation and replenishment through little heart-shaped blow-holes. But the overall scene lasted as long as their welcome company – the warmth of their sunlit shapes in clear air, in contrast with a remote, cold and more etherial image from the undersea.

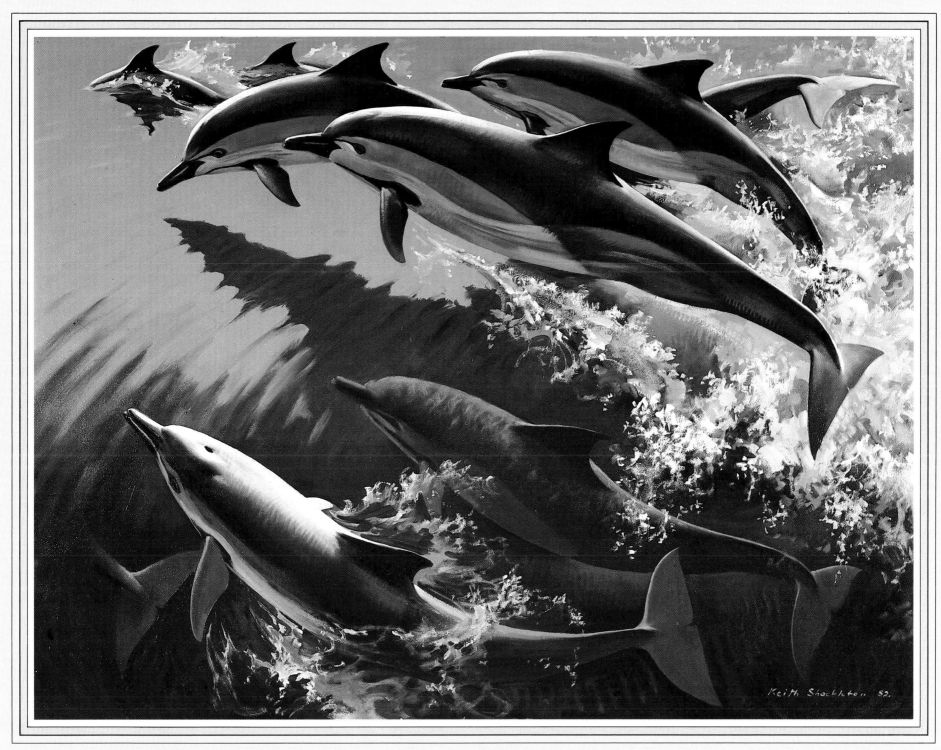

Keith Shackleton 82.

36″ × 48″

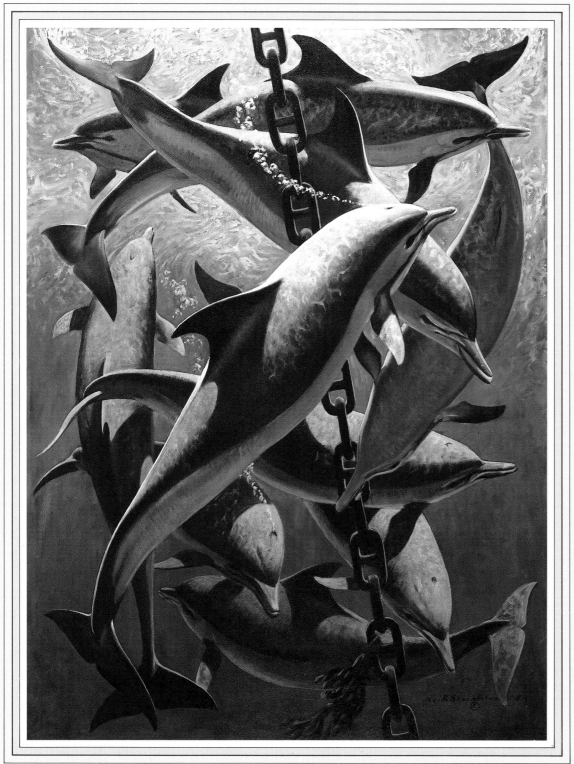

40" × 30"

DOLPHINS AT THE CHAIN

I watched this happen in the Galapagos Islands and the memory of it held such immediacy that it became printed on the mind. Years later the moment was suddenly right, and the picture began.

Dolphins were stropping themselves against the anchor chain as cattle use a rubbing post, but with their own splendid grace. They slid up and down and over, weaving and spiralling in a perfect piece of choreography. "Poetry of motion" was how a shipmate described it.

The uncompromising geometry of the chain worked wonders with the bodies of the animals and held the picture tightly together in my memory. Only when it was actually begun did I discover how sketchy had been this mental photograph. Before the picture was finished I had added extra dolphins and painted others out; changed a position here and a direction there and embarked on a general orgy of indecision – grateful throughout however, for the good properties of oil paint, so forgiving to those of us unable to make up our minds!

WINTER IN THE NORTH SEA – BRENT BRAVO

There has always been a custom in the Royal Society of Marine Artists that the President writes a foreword to the catalogue of the annual exhibition. As each President lasts for five years, and there have been quite a lot of Presidents, with each one reluctant to recycle the old messages of his forebears, a new theme becomes increasingly hard to find and despair looms imminent.

When it became my turn, I did all I could to prod an atrophied mind into ticking, but to no avail. I was close to moral capitulation when an old axe of mine rose like a rusty Excalibur, and presented itself for a re-grind.

My foreword put the suggestion that contemporary artists really should paint the contemporary scene as experienced in their daily lives. We should record today for the sake of tomorrow, but nostalgia for a beautiful maritime past under sail is unavoidable as it is understandable. My point was simply the degree of indulgence we should allow ourselves. It would be good, I was suggesting, not that there should necessarily be fewer tea-clippers in the Trades, Drakes rounding the Horn and reconstructions of Trafalgar – just more supertankers, roll-on-roll-off ferries – and oil rigs.

It was a re-grind because I had mentioned it before to the Guild of Aviation Artists – the thought that Hogarthian scenes of queuing for the loo, and killing time in soul-destroying transit lounges, was as much a part of aviation as Sopwith Camels in Flanders.

Perhaps it was unfair to pick on shipping painters when my own interpretation of "marine" embraced either the eternal element itself or animals that have moved through or over seawater for some millions of years, before anything that even looked like a human being appeared on the planet – let alone a ship!

This picture came as a curious sequel to the foreword. Out of it, with timing that betrayed a neat sense of irony, I was commissioned by Shell Expro to go to the North Sea and paint an oil rig. "An oil rig," I said in amazement, "me?"

"Yes," they replied, "you. You see it is essential that contemporary artists should paint the things . . ."

It was a lovely thing to work on; the North Sea in winter is a comfortless place, but the rigs were all warmth, strict discipline and an all-round feeling of competence and technical expertise. Nobody spared any effort, especially the helicopter pilots who would sit about just above the waves while I drew things, for as long as I liked. Shell had made no strictures in their brief, just the atmosphere and of course – a rig.

There was plenty of both about for those few days, and though I lived on *Brent Charlie* my favourite became *Brent Bravo* just for her mammoth qualities of contemporary sculpture, for the angle of her jib; and so it is she in the painting, standing there like a vast Aladdin's lamp on elephantine legs, straight out of the ocean. And the subject brought some strange sort of moral boost to me – if only because contemporary painters should try to . . .

18″ × 30″

94

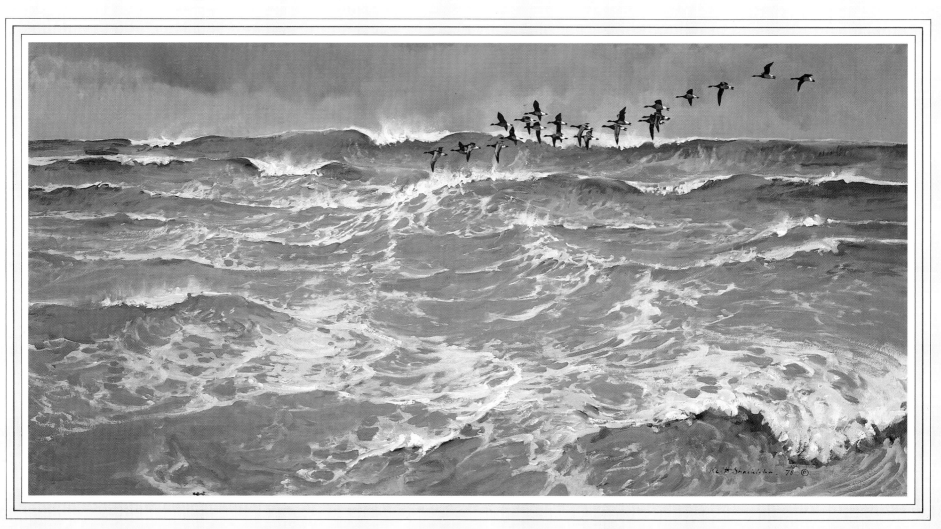

24" × 48"

Brents Over the Harbour Bar

They arrive each year in the autumn, around mid-October. The date is somewhat flexible because of the weather conditions they experience on their way through the Baltic. All in all though, they are surprisingly consistent.

Most years I hear them first at night. A strange, rather eerie sound that is hard to define, a babble, a clamour comes fairly close to it, with conversational undertones more like squeaking. The sound rises and falls with the wind across the mud flats and when dawn breaks they would be out there, clearly seen from the bedroom window, destined to be with us until the spring.

This race, the dark-bellied Brent goose, breeds in Novaya Zemlya, a great crooked finger of an island separating the Barents from the Kara Sea, north of the Soviet Union. It is a small and compact little goose, black, white and charcoal grey, always sleek and well-groomed with a surface like the bloom on a ripe damson.

As the winter proceeds, so does their tameness until they are almost up to the window, grazing around the upturned boat and only swimming a few yards clear to let me pass through when rowing up to the mooring.

They leave at about the time the first terns arrive, so that their parting is leavened by the stream of new spring migrants. But throughout their stay, the sights that give me the greatest pleasure are the writhing chains of their flight, strung out like beads on a rosary, sometimes hidden by waves, low over the sand-stained turbulent seas that break on the Harbour Bar.

The sea has a rhythm of great regularity, sweeping in over sand and gravel that is shelving and shelving until each successive roller reaches its breaking point, curls over for its full length, surges down its leading edge, disperses into a haphazard swirl of white water and is gone to make way for the next. The seas are spent now because they have run into the deeper water of the channel but they keep on coming in from the south, rearing up, curling, breaking and dissolving, and the strange call of the geese is for once almost inaudible above each crescendo of the sea.

PINKFEET AT CLOUD HEIGHT

I was once an aviator; not a very good one, but I enjoyed flying and felt a lot safer driving a little aeroplane than a little car. I thought the sensation of aerobatics was disgusting – particularly that of hanging in the harness while small bits of rubbish from the cockpit floor fell into my face. So I flew principally because at the time it was part of my livelihood, but when I did it for fun it was not so much for the physical sensation as for the view of the country below, to see lovely things from different angles and savour the excitement of stealing a march on nature.

So it happened that one day on a flight up the east coast to deliver an aeroplane to Newcastle-upon-Tyne, I came upon a little party of wild geese at cloud height – flying south on their autumn migration.

I turned and stayed with them for a little while. They looked great and were where they belonged, yet in circumstances that for once I could actually share, and looking down on their backs, I felt both lucky and privileged.

36″ × 48″

20″ × 48″

CROWD SCENE

Waders are the most gregarious of birds; allowing themselves to be concentrated not just in countless packs of their own kind, but in assemblies of many different species together. And it is all dictated by the rhythm of the tides.

A high spring flood not only restricts the choice of roosting space, it diminishes the area of those that remain by inundating all the low-water feeding grounds on the littoral flats. High water becomes a social period like it or not, a period of temporary but unavoidable fasting, of resting, preening, chatting and waiting for time to pass.

Such concentrations always tempt one to search for a rare vagrant standing one-leggedly among the pack, half hidden perhaps behind someone bigger and taller, like trying to spot a Chinaman at the last night of the Proms. To birdwatchers it is a familiar scene, and a fascinating one, not least because of the far travellers always present in such a get-together. Birds like the Knot winter as far south as the tropics but breed high into the Arctic tundras. It is also very much a winter scene. I have watched it often and promised myself to paint it a hundred times; I imagined the subject calling more for care and concentration than creative fervour, and an exercise that certainly would have to be tackled some day, if only once.

I suppose it could be called a composition within my old art master's definition, but a "pattern" was more what I had in mind, so much so that in certain areas a potato cut, a rubber stamp or a stencil would have helped a lot! Working on it was much like keeping a tapestry rolled up and adding a few stitches to fill time when someone has run off all the bath water.

There was no special need to plan the whole picture. I began by simply drawing a bird, a Dunlin probably, somewhere up on the top left hand corner, and when the next bit of appropriate paint was left over on the pallete from another picture, I would remember the now growing crowd scene, put it on the easel and whizz in a Godwit. Bit by bit, bird by bird, the canvas became stocked; but there was always a corner for just one more – the odd Little Stint or Curlew Sandpiper – ornithological opportunism of a shameless kind.

There are few rules to making this sort of bird pudding, but to me anyway they are important. One is that birds facing the edge of a picture look horrible if their beaks are skewering the actual frame. Another is that the head of a bird is sacrosanct: never sever a head. While a head looking into the picture is fine, a decapitated tail end on the outgoing side is quite unacceptable.

Because waders, and indeed all other birds including weather cocks, face into wind, this matter of the heads is an important issue. In this picture it dictates a direction of stance and interest from right to left which inevitably calls for some planning down the left hand side. One little ruse was the Redshank momentarily turned downwind and displaying the obvious result: it helps to redirect the interest from this critical border back into the main throng.

In an hour the ebb tide will beckon them back to the fossicking grounds on the newly exposed flats.

In a month or so the whole scene will disintegrate for the summer. Migrants will be heading north; residents, paired off, will seek nest sites among the enticing acres of shingle, sand and grasses beyond reach of the highest tides.

Falcon on the Wind

There are two birds whose call seems to have been composed with the greatest sensitivity, just to be in keeping with cloud, wind and the height of the sky. One is the Curlew, the other the clear, excited cry of a Falcon. The voice will often catch the ear before the eye spots the shape, preparing one for this little apparition high up there and at home.

The Falcon outline is a classic: there is something startlingly precise about it, so entirely functional, so exquisitely proportioned that the bird is in a class of its own with a pedigree to match.

The first spark of inspiration for this picture was struck, of all places, in London W.11. It was a boisterous day in the autumn with fast moving clouds that have that rare property of taking the thoughts away with them along a unique escape route to somewhere far removed from spires and domes, tower blocks and the roll of traffic.

It was a single bird on passage, slipping over the metropolis probably for the first time, and taking everything entirely at its face value, a landscape – an unusual one perhaps – but no more than the ground below that is there for passing, something that a good pair of wings can reduce to an ephemeral smudge of little consequence.

I wondered if it had an eye lifted for one of the fat pigeons nourished on the fleshpots of city life, or perhaps a Mallard, gorged with soggy crusts from St James's Park lake. Sometimes Peregrines will stay around and take advantage of such easy pickings, but this one seemed to have an enviable purpose, just to let a helpful wind take him on his way, and it was more or less where I wanted to go myself.

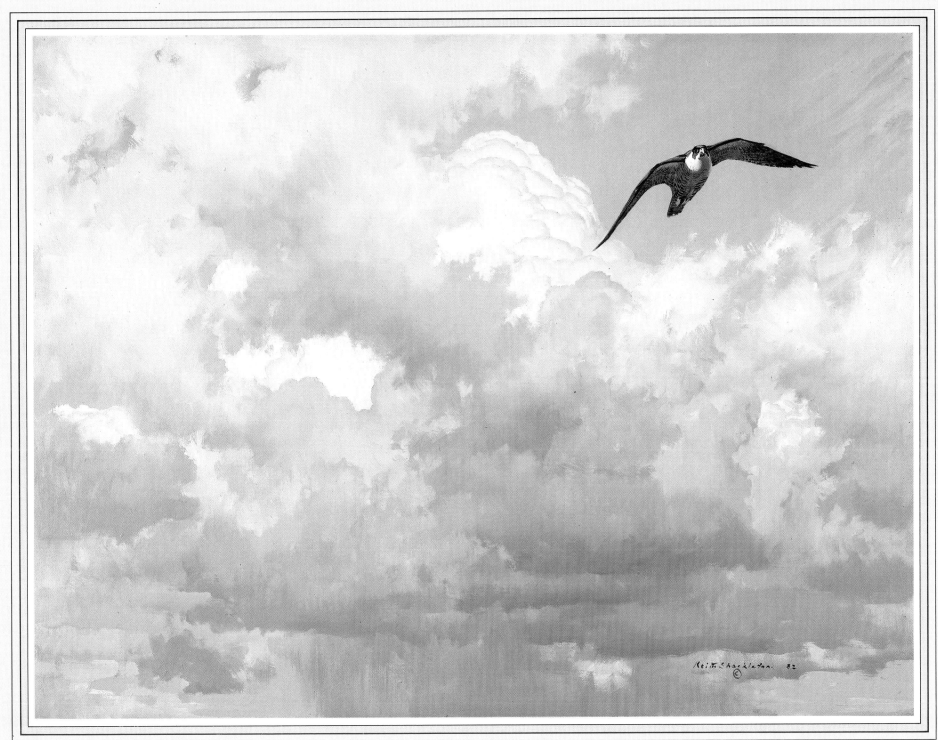

30" × 40"

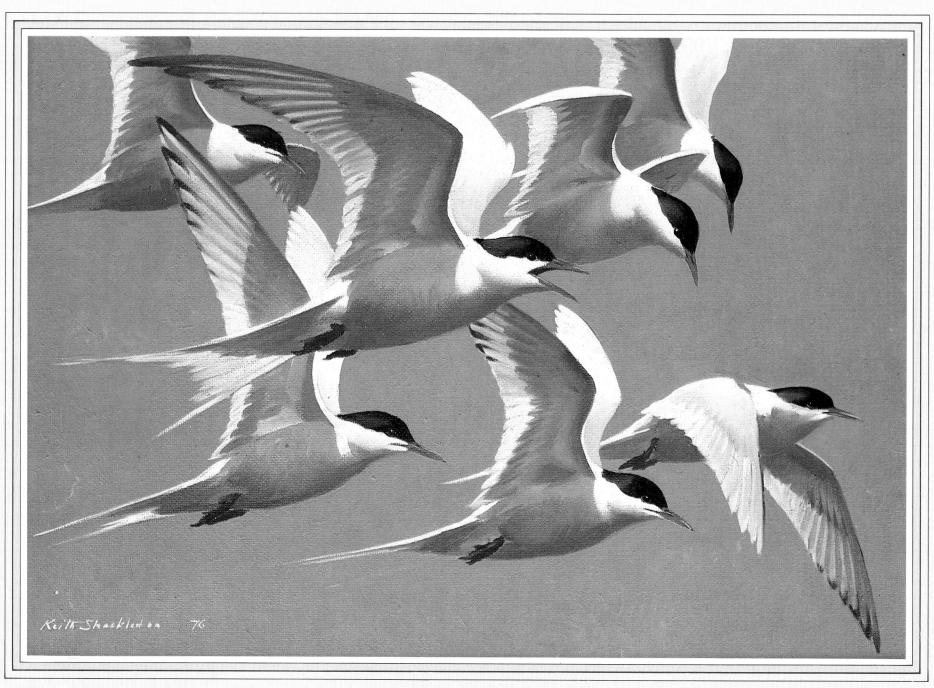

18″ × 24″

Arctic Terns

One statistic alone puts the Arctic Tern into the most elite category of birds. It is the furthest travelled animal of any kind on earth.

Its gentleness and apparent frailty make the feat the more remarkable and it is only when you consider carefully the implications of this annual journey that you begin to realize what being an Arctic Tern must be like.

Starting on a midsummer day in the Arctic, at a latitude that could be as high as 80°N, and finishing in the same place, on midsummer's day of the following year, the bird will have covered a minimum of around 20,000 nautical miles. This is assuming a fairly direct flight south to the Antarctic Circle and back. It takes into account none of the hunting flights to feed the young, none of the casting about on the long journey to fend for itself.

One thing is certain. It will see more daylight than any other bird because its year will contain twice as many high-latitude summers. Virtually the only darkness it will know will be in the brief double transit of the tropics.

I have seen them in this half-way period – sometimes resting on driftwood in the Doldrums. I remember one little row of them on a waterlogged plank floating flush with the surface and unseen as we approached, so that the birds seemed to be standing Christ-like, on the water itself. Another I remember off the coast of Senegal, balancing on the neck of a bottle as it bobbed from side to side like the arm of a metronome.

When they reach the southern ice they are in the territory of the very similar Antarctic Tern, in the midst of its summer breeding cycle. But they can be easily told apart because our northern one is now in its winter plumage – a white brow and a blacker bill.

One of the byproducts of ornithology, however, is human confusion – so please bear with me. While the adult Antarctic Terns are looking much like the Arctics in my picture, their full-grown young go straight into a winter plumage. If Arctics were still about then, I for one would be finding great problems with their identity. Fortunately the overlap would be short-lived. The Arctics by then should be well on their way with 8-10,000 miles to go, while their Antarctic lookalikes stray no further north than Capricorn.

Each time I see one of these utterly beautiful little things, I feel the same stirrings of total wonderment. All that distance, all that navigation and all with "instruments" the size of a cherry-stone.

They have a sharp clear cry that announces their spring arrival in the north and it is one of the most stirring things I know – not because it is a lovely sound like a Curlew, but because it proclaims such unparalleled achievement, an annual routine which will have been repeated without a break over eons of time.

But only the first Cuckoo carries influence in press circles and rates a mention in *The Times*.

NORTHWEST TERRITORIES: SIXTEEN SNOW GEESE

From time to time among the great flocks of grey geese wintering in Britain there will be a single white bird, standing out like a bullseye in a box of chocolates. It could be an albino of the main species, or it could as easily be a Snow Goose.

Such a stranger is happier in a community of geese, even of another species, and probably travelled with them all the way from the northern breeding grounds. It will stay the winter and return to the northland in spring where it may sort itself out, join up again with kindred birds and resume its yearly migrations on more conventional lines among others that are all white with black wingtips, just like itself.

My picture is of the Snow Geese at home in the Arctic spring. They breed on the tundra slopes at points around Hudson Bay and up in the great islands of Canada's Northwest Territories. Their traditional winter range extends as far south as the Gulf of Mexico and it is from this stock and this area of movement that the occasional vagrant absents itself to winter in Europe, bringing with it all the romance of a far traveller.

But not all Snow Geese are white. There is a widespread slaty-grey form with only its head white – the Blue Goose.

It is said to be a colour phase of the same species, and certainly it is not uncommon to see a white one and a blue one paired and with goslings. Moreover it seems that the blue form is dominant and mixed parentage will tend to produce blue young.

So the Blue Snow Geese are a very frequent summer sight in the Canadian Arctic, their V shapes and chains lacing across the sky, and their clear, exciting call carrying across a wide landscape. Dotted among their flight patterns will be the occasional white one, and the spectacle carries with it all the visual joys of wildfowl the world over.

But every so often one comes across a group that are all of the white form, and it is then that a certain tidiness and purity is added to the scene – a purity in fact, that is no less evident in an all blue muster. Standing on the russet tundra the white ones look whiter than white, flying against the high ground still covered with winter snow; the name "Snow Goose" – like the Snow Petrel of the south – seems to acquire its apt and proper meaning. I would never challenge the beauty of the blue form, it is just (and please may this not be misunderstood) that I think the white ones are even more handsome.

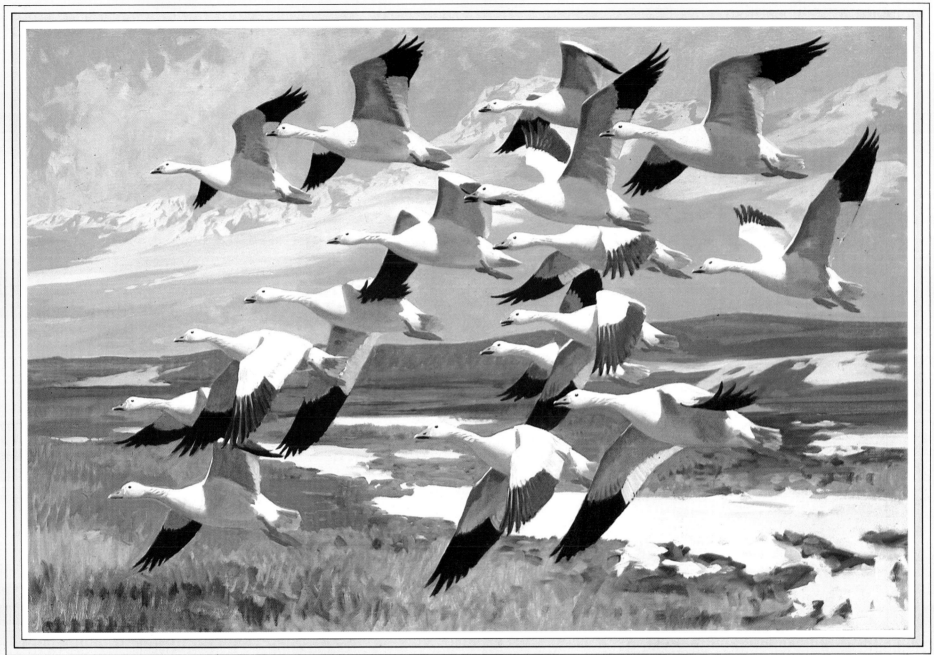

24″ × 36″

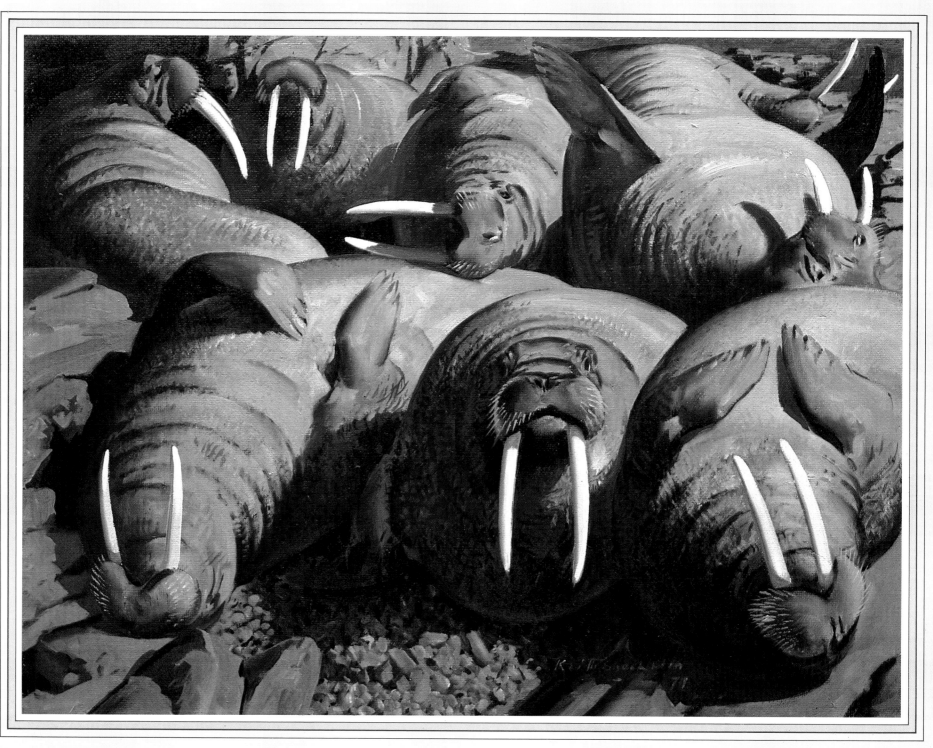

18" × 24"

SIESTA BY THE BERING SEA

Someone suggested that this was a group portrait of the selection committee of a well-known art society in deliberation over submitted work. In my view that was uncharitable in regard to the level of attention being paid rather than the physical appearance of the subjects. Walrus are unreservedly lovely.

In many ways they are like maritime elephants. They have elephantine charm and an elephantine texture, and texture is very much what this picture is about.

The smaller, grey beach stones are an expanded version of the roughness of a Walrus hide; the larger boulders are often a repetition, a parody, of the whole Walrus shape, but wave action has given them an altogether smoother finish.

Tusks provide the ultimate accent of contrast: erupting from the toothbrush top lip, the smooth curving white ivory can reach three feet in length. Wherever you look over a beach strewn with abandoned somnolence, it is the tusks that catch the eye, the paired clothes peg effect pointing in every direction and catching the light. Sometimes there are hundreds together on these favourite congregational beaches that the Inuit peoples call *ooglit*. The colour is mute but still the tusks dominate. A life at sea keeps them whiter than an elephant's and wetness makes them flash.

When Walrus first haul out, they are grey-brown like the rocks, but on a warm sunny day they quickly take on a startling pink, so pink that from high above, with half-closed eyes, the general effect is of a beach strewn with rose petals, but still the tusks stand out and dominate the pattern. Sadly it is the tusks of Walrus, like the tusks of elephant, that covetous man kills for, and the use to which he puts them is as frivolous as it is unjustified. It is a tragic piece of irony that something developed over millions of years as an adjunct to the evolution of a successful animal, should be turned, almost overnight by a human whim, into the very cause of its demise.

OVER THE BANK: NORTHERN EIDER DRAKES

Eider drakes do two very convenient things for painters. The first and more obvious is their very paintable markings and colour scheme – the striking black and white, the pinkish breast, apple green head patches and yellow bill. The other benefaction they have to offer is a habit of seasonal segregation of the sexes, resulting in great rafts composed of drakes alone. Thus they present an exclusive gathering reminiscent of the anteroom at the Royal Aero Club in the early afternoon.

There are of course rafts of females too, equally exclusive, bobbing about on the swell in just the same way, but through the eyes of a painter lacking the aesthetic magnetism. The Eider duck is a lovable animal in a thousand ways: the black and tan barring, a discreet and tasteful pattern, the profile clean and chiselled as in any drake. Perish the thought that the slightest hint of chauvinism is lurking here, but a truth must never be side-stepped whatever the consequence. She simply does not have the brush appeal of her mate.

After a long association with Eiders, creating a sudden urge to go and paint them, I roughed out a grouping of both sexes together, even to the extent of deciding which would be which and sketching in with charcoal the patterns of each one. It was only when I started with the paint that a shameless, existentialist abandonment set in. I aborted the whole idea in favour of a surfeit of drakes, and one by one the ladies fell to a mass sex change, acquiring in a few determined strokes the voluptuous double white pillow backs and candy striped faces over what I had originally planned as a dappled imitation of houndstooth tweed.

This kind of indecision would never have happened with penguins or any other of those birds in which, to us anyway, the sexes are identical. The groupings of such birds are more visually cohesive, with the sex of each individual discernible only through little giveaway snatches of behaviour. It is still possible that I may vacillate some more, suffer a token pang of conscience and turn one or two of these drakes back into ducks again, but if I do it will be too late to catch this book.

It is the way I always remember Eiders, in a steep but benign swell that builds up over a shelving bank on days of misty calm. The sea plays a form of hide-and-seek with the birds. On the face of each swell the raft is stretched and compressed and stretched again, like dough in the hands of a pastrycook, and every so often a whole section of the pack will subside into a passing trough and be momentarily lost to sight. In the next instant they reappear, buoyed gently up in a looser formation, with each Eider riding like a cork float on the headrope of a net, in concord with the gentle rhythm of the swell.

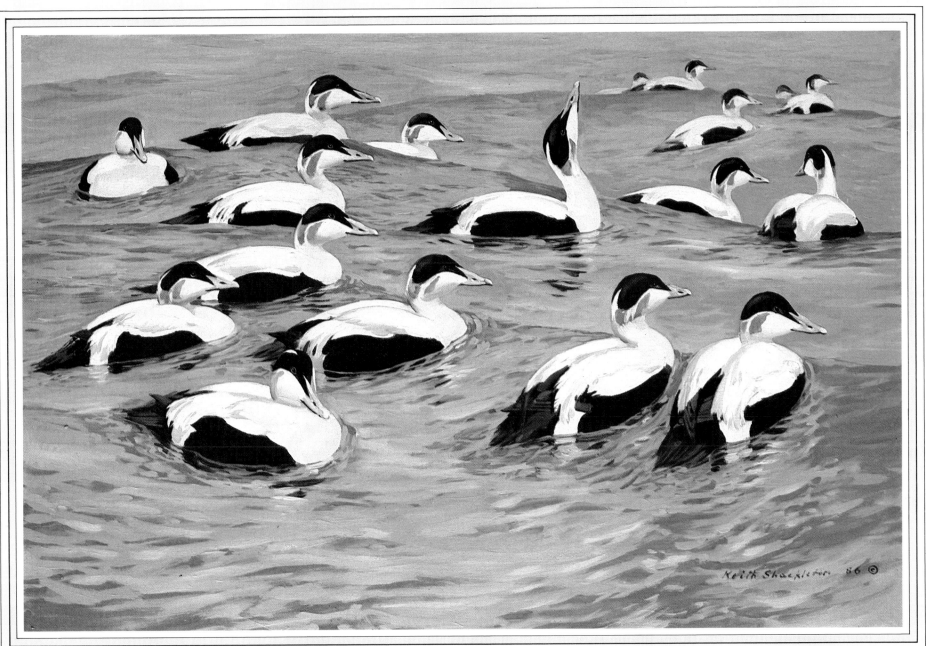

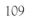

24″ × 36″

30" × 40"

NORTH TO THE ARCTIC

79° 21′N, 71° 33′W

The reason this picture has such an obscure title is because this is the only way of expressing the exact location of the subject.

To save the search for an atlas, these coordinates fix a point in the Kane Basin – a wide sweep of sea, or more generally ice, dividing northwest Greenland from the opposing land mass of Ellesmere Island to the west.

It was the furthest point to the north that we were able to reach that year, and when the little vessel finally ground to a halt in ice that would have been wearisome to force when no practical purpose demanded it, we backed off and turned south again. But at that very point two polar bears were there to greet us.

There are two things that register immediately on the first sighting of a wild polar bear. For the world's largest carnivore, they look smaller than expected. For an animal always thought of as white, they are a great deal less white than ice and snow. Both these comparisons are in a way artistic because they dictate the way a painter must treat the animals in relation to their landscape, to give some measure of conviction.

There is a legend in the Arctic, that the ice bears are conscious of their obtrusive black snouts and muzzles, and when down on their bellies and squirming towards an unwary seal, they will hold their paws in front of their faces in an act of concealment until the moment to pounce. Perhaps one day I will see this happen. There is plentiful evidence to suggest an instinctive awareness of tone and colour in animals, used for defence as much as attack.

The ice shapes, too are strangely local. Platforms with thick, mushroom-stalk legs crop up again and again in the Canadian Arctic, with many a convoluted explanation for their happening.

This tip-tilted, crashed billiard-table of a shape, forming a crazy bridge, is abstract bordering upon surreal. By contrast polar bears are warm, homely and more understandable – a comparison that can best be appreciated at close quarters, from behind the steel bulwarks of a ship.

MOUNT GARELOI, ALEUTIANS

No wind all night had led to a glassy calm by daybreak. Between filmy layers of mist, little parties of Short-tailed Shearwaters chased along, pivoting back and forth with wingtips an inch from the sea. Every now and then a thicker fog bank would cut visibility down to a few yards, single birds would pass ahead as half-seen ghosts, flying on their instruments, dead on course. The ship would suddenly break into the clear again and a hundred more would be there with their strange searching sort of flight, all going the same way towards Tasmania and the Bass Strait at the other end of the Pacific.

I had been on the bridge-wing since first light, sketching not so much the shearwaters as the strikingly symmetrical cone of Mount Gareloi, standing dead ahead out of the mist. From its summit, a great architectural cauliflower of a steam cloud rose to dwarf the mountain, than flattened its top to an anvil shape, stretched away to oblivion, cumulus into cumulostratus, parallel with the sea mist and the veiled horizon.

As the sun mounted, it struck the higher levels of the growing cloud, then crept downward with astonishing speed finally to burn off all the surrounding vapours and throw the scene into the sharpest clarity. It was the kind of early vigil that gives a very good appetite for breakfast.

Looking at the sketches afterwards in the studio in England (a deal closer in direct distance than the shearwaters were from home), I reached the decision that the best moments had been the earlier ones when the low level sun had reached only the steam cloud and then only through a filter effect of mist. The thought was also appealing to me that the shearwaters had known where they were going, even when there was nothing to be seen.

But what struck me most, I think, after I had got over the tragic incompetence of my watercolour technique, was that there stood a mountain, sea all round it, both sides an equal slope, a flat top with the cauldron-spill effect of white ash, and the huge bubbling cloud. It was an almost exact replica of a picture in my first geography primer with the caption underneath saying "This is a volcano".

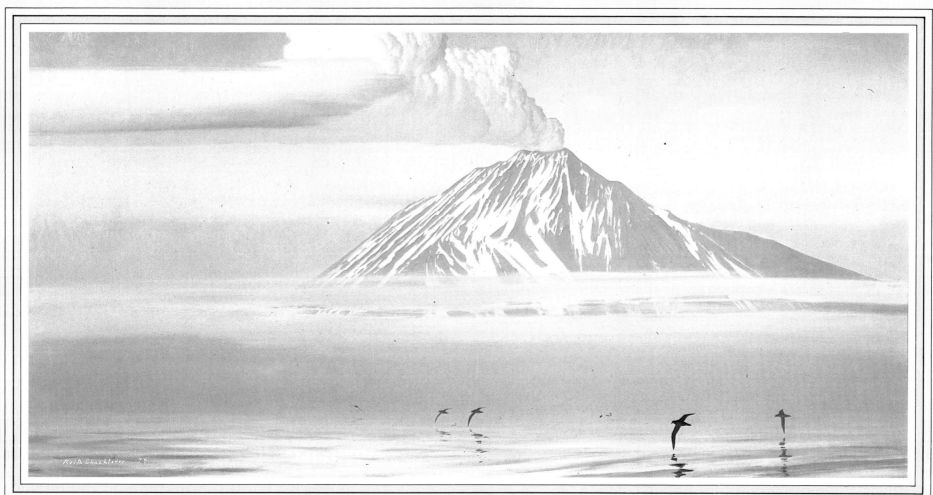

24″ × 48″

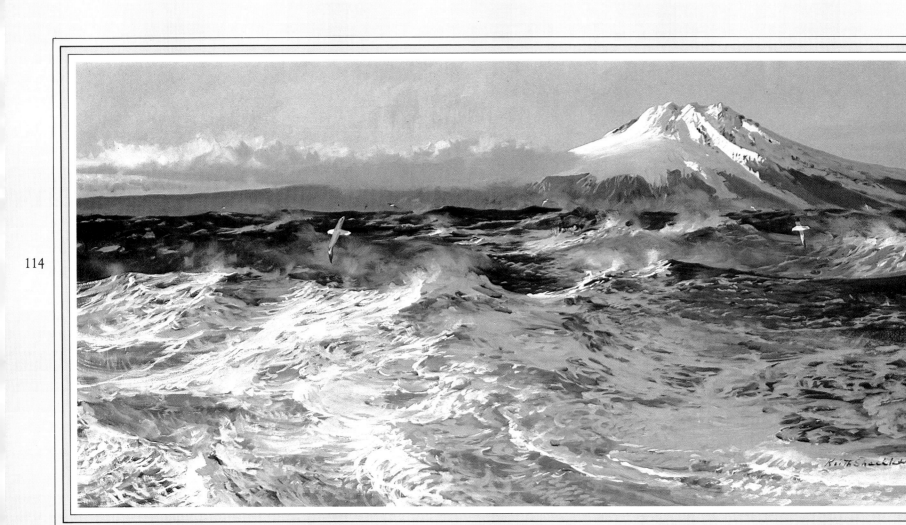

114

18″ × 36″

JAN MAYEN

"Those sitting on the right hand side of the aircraft" came the disembodied voice of the captain "will enjoy a very fine view of the Arctic island of Jan Mayen."

Sitting on the left, I jumped up like a startled redshank and with apologies for urgency, scrambled over to an opposing window that offered a view unimpeded by wing or engines. And there it all was. Unbelievable.

A good view of Jan Mayen was something I had imagined on the same level of probability as getting a good view of the Queen by walking past Buckingham Palace. The island, which lies pretty well exactly between Iceland and Spitsbergen, has a reputation for cloud, mist, icing and general meteorogical inclemency yet here it was, lying warmly across a wrinkled sea 35,000 feet below. The snow slopes of Mount Beerenburg shone like crystal and the rim of an extinct crater threw a deep shadow emphasizing the dimple in her summit. There was not the smallest puff of cloud. Looking far to the north, the hard line of the polar pack ice lay across the horizon.

Until then, Jan Mayen, as seen in this painting, was the best view I had ever had, and I suppose a typical one. The cone of Beerenburg was often clear at a distance but screened by cloud on closer approach. There seemed always to be a gale of wind, and Fulmars on their stiff wings were there in plenty. All this had appeared in the first sketches. What bothered me was how to achieve the impression of the island drawn back and distant, when its shapes and colour so clearly resembled an extension of the foreground sea. There was little chance of offering a contrast in tone without losing conviction, so once again it had to be colour and colour alone that could do it.

In the end, the warmer and more violet shades of the land seemed to make a more or less adequate separation from the blues and greens of the sea. I suppose it was as insignificant a painting discovery as any that have been made, but at the time it afforded me much personal pleasure – like dreaming up a new fold for a paper dart and finding that it actually flew.

45 COMMANDO

This picture was commissioned by the Royal Marines and the brief that went with it was as simple as it was stimulating – to go to Norway in winter, join the Commando on its exercise and paint a picture that conveyed the atmosphere of preparedness training for NATO's Arctic and mountain role. With the benefit of hindsight, the rigours of this hair-shirt sort of training certainly paid off. Seven years later this unit 'yomped' from San Carlos to Stanley and liberated the Falklands.

Shortly after returning, I was asked to write an account of the experience for *Globe & Laurel*, the Royal Marines' magazine. Because these thoughts were contemporary with events, I have taken the liberty of quoting extracts.

"One can never afford to set out on any painting assignment with preconceived ideas; they are always flattened by fact. So I have learned that however uncertain one may be at the outset, the message sooner or later will strike – as it did St Paul on the road to Damascus. The scene will suddenly be there. An idea, a concept, will present itself like an apparition and crystallize into something that conveys it all. The only certainty I felt was that this vision could only be found in the field, seeing and feeling the same conditions and carrying the same loads. My only misgiving was the risk of holding up the whole proceedings while the tragic remains of Shackleton were transported home by helicopter from the mountain fastnesses of Northern Norway."

". . . there was nothing new in the climate; but fighting a battle is very different from the unhurried sketching of wild animals with no time limit on the exercise. Not surprisingly, it was this very distinction, this overall urgency of a military purpose, that formed the concept of the picture."

"When finished it will portray men – a small number of men – skiing uphill, in windy, joyless, grey, cold weather. Uphill because this seems to be the pattern of Arctic warfare, as it came across to me. The downhill St Moritz image is out, together with the Kodachrome shadows on sunlit snow, the amethyst-coloured distance, the stratospheric blue of the sky. This has to be a hard, cold place to prove a testing ground for human endeavour . . ."

There followed a paragraph about such esoteric subjects as ski-waxes and margarine (which were in fact strikingly similar) and various other dietetic breaks-through, so fortified with concentrated nourishment one might have expected to glow in the dark. Then the account ended . . .

"A final discovery will remain a happy memory – that men who are so painstakingly trained to kill their fellow men with such clinical expertise, should be so kind and considerate and good to be with. The extra daily content of humour must provide as many calories as the 'Curried Beef Granules'.

"This was one of several points coaxed out of me by the Norwegian press. They were also anxious to know the meaning of the initials RSMA they had seen after my name. The reporter, I felt, was fascinated that there should be, in Britain, a Royal Society of Marine Artists – a whole Society with 49 members – formed and functioning for the exclusive purpose of painting Royal Marines! Only the British, I sensed him thinking, could be quite so nuts."

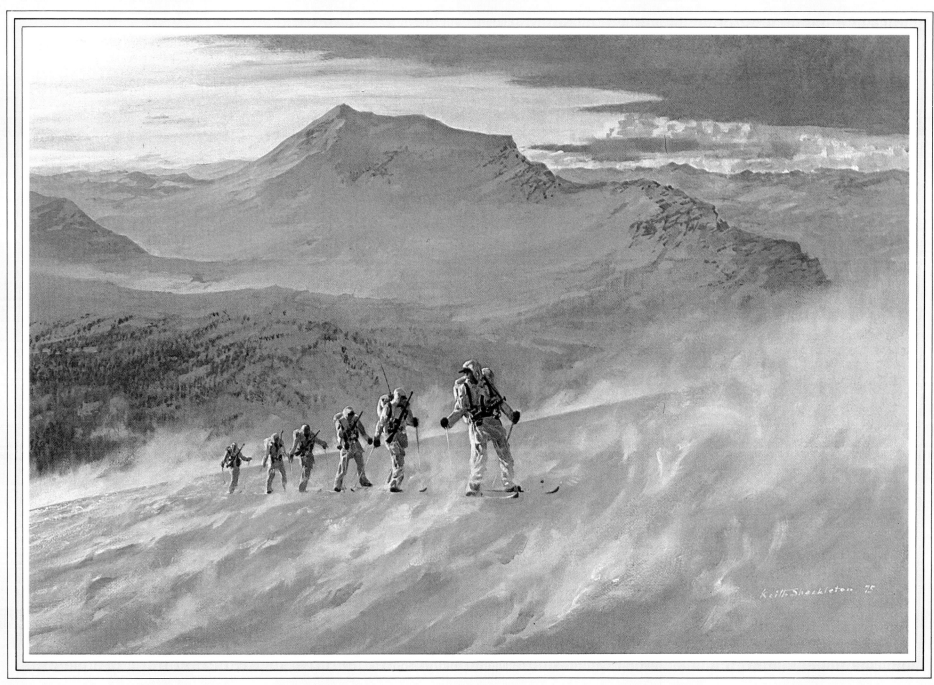

24″ × 36″

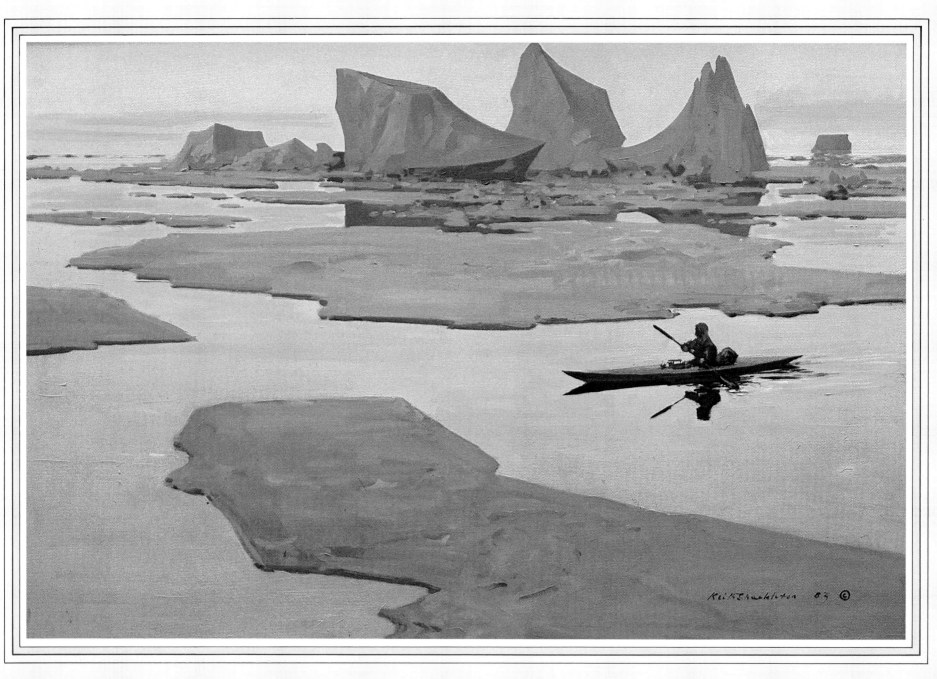

24″ × 36″

September Midnight – Scoresby Sound

Alaska, northern Canada and Greenland have the Inuit; Siberia, the Chukchi, and all are thought of loosely as Eskimos. Theirs must be the most specialized adaptation of the human species ever achieved. Man in biological terms was intended for warm countries, yet these people have taken for themselves, by ingenuity and determination, a unique niche in the world, the high Arctic, and here they survive in climates that would kill a naked man in ten minutes.

In the course of adaptation, the savage climate and little else, has moulded their bodies, their minds and their culture, until now. Recent years have brought many changes to the Inuit and to their destiny. Ethnic autonomy fights a losing battle with the 20th century and the first casualty is invariably the independence that goes hand in hand with isolation.

Arguments are raised for which there are no answers. There is simply a process under way which is totally unavoidable, includes influences for both good and bad and seems to call for ever more urgent decisions.

But here and there all over the Arctic, you may still see the old traditions at work. The big communal *umiaks* and the slim single-seater *kayaks* of stretched Walrus skin over wood frames are still built, and more important, still used in the hunt. The Snowmobile and high velocity rifle have not entirely supplanted the rewards of a more basic and personal sense of achievement. This is a good thing. It must help in its own way to keep the new firepower and mobility within responsible limits. But it also provides a subject I find enormously appealing.

He was paddling through the ice close to Cape Brewster in East Greenland. It was midnight in the autumn. The sea and sky were all over saffron yellow, turning the ice a most improbable blue, and the man in the kayak, like some water insect in so vast a place, looked diminutive yet heroic.

I know I am an old sentimentalist, but nothing would have persuaded me to paint a figure in a scene like this driving an aluminium dory with an outboard motor.

In my thoughts on painting at the beginning of the book, I tried to seek out and name some of the ingredients that make up the strange and very personal phenomenon we call *inspiration*. "Tried", I fear, is the operative word.

But there would be little spice in life without its enduring mysteries.

PUBLISHER'S ACKNOWLEDGEMENTS

The publisher acknowledges with thanks the advice and encouragement of Ian Niall who gave us the title; David Burnett who rightly suggested we hold to a polar theme (despite the agonising decision to discard wonderful paintings of leopards, tigers, elephants, Masaii warriors and other tropical subjects); Bob and Dick Lewin, Sir Peter Scott, Lord Buxton and June Holloway whose words of advice at various times have been of great benefit.

We are particularly thankful to Ted Sheppard whose enthusiasm, generosity and practical help was altogether invaluable. We should also like to record our thanks to Hugh Wickham and Chris Bullock of Shell UK Ltd who, with Ted, were responsible for the most generous pledge of sponsorship.

Others, whose expertise has been called upon, are Nigel Partridge, Edward Bunting, Geraldine Prentice, Mike Fear, Robert Aspinall and Terry Pickering; we thank them for their important contributions, particularly in the matter of meeting deadlines.

We are grateful to J M Dent and Sons Ltd, Peter Shellard and Liz Newlands; Gaia Books, David and Joss Pearson, for their co-operation in helping us to take advantage of the publicity and other opportunities afforded by the simultaneous publication of their book *Ship in the Wilderness*.

Finally our thanks to Keith and to his wife Jacq. For their hospitality, friendship and for making this book so much fun to produce.

120